WITH INTRODUCTORY ESSAY
BY MIKAEL WIVEL

PER **ARNOLDI 250 POSTERS** ETC.

BIRKHÄUSER - PUBLISHERS FOR ARCHITECTURE
BASEL · BOSTON · BERLIN

"Art is communication is art..."

Per Arnoldi

Mikael Wivel

INTELLIGENCE AND POETRY

It is hardly a coincidence that Per Arnoldi has officially been asked to design the logo for the worldwide celebration of the Hans Christian Andersen Bicentenary in 2005. For if anyone in Denmark has understood Andersen and responded to him – in a contemporary way – with images of the same subtle precision as those the writer sprinkled through his tales, then it is Arnoldi. He may not actually have illustrated Andersen – strictly speaking that is impossible, since the texts illustrate themselves in the mind of the individual reader – but at one point he came very close, as close as one can get nowadays.

Characteristically, it happened in one of his posters, the part of Arnoldi's many-faceted oeuvre that comes closest to the illustrative. And it happened in 1993, as part of the campaign on which the French firm JC Decaux launched him, in connection with the advertising stands and shelters that the firm was setting up all over the country. One of them is an absolute bull's-eye – the one that promotes the city of Odense.

What do people think of all over the world when they think of Odense? Exactly – they think of Hans Christian Andersen and his tales. And which of these tales do they think of first when they think of Andersen? Right again – the autobiographical *The Ugly Duckling*. And so too with Arnoldi, who with his usual precision has homed in on the finale or moral of this in many ways painful tale – the famous sentence, "No matter if a

bird is born in a duck-yard, if it is hatched from a swan's egg."

How does he visualize this dictum? How does one hit off the central point in this triumphant conclusion to the duckling's tribulations? Arnoldi's solution can only be called inspired. His ugly duckling glides, black as coal, over the dark blue water, against the background of a deep blue sky, while below it, on the surface of the water, it is reflected – not as it is, but as it is to be – as a magnificent swan with beating wings, white as snow. With a simple authoritative device Arnoldi has summed up the whole tale – entirely without sentimentality, but with a disarming humour akin to Andersen's own. It could not have been done better. The poster – like so many of Arnoldi's – is a born classic.

It is furthermore extremely characteristic of his 'late style' as a poster artist: tight in its composition, simplified in its line and sparing in its use of colour. The components are few, but the effect is strong and the balance optimal. In every way the message hits home.

Sea and sky take up equal space in the picture and are constituted by two shades of the same blue colour – a colour one is tempted to call 'Arnoldi blue', because he has made use of it so often that it has almost taken on the character of a signature. The duckling and the swan have been placed right at the centre of the picture, where they are unfolded

like a paper cut-out along the axis where sky and sea meet – like two sides of the same thing, just as in the tale. And they are both drawn with a simplicity that approaches that of the pictogram, and which can be interpreted immediately by everyone – in passing, so to speak, like a road sign. Everything stays at the surface; not that this means the picture lacks either perspective or psychological depth.

It is wonderfully done, and quite in keeping with Andersen himself, who was so amazingly succinct when he wrote; not that this meant he got less said than his more verbose colleagues. *The Ugly Duckling*, for example, fills only eight pages in an ordinary edition of the tales, although a whole world unfolds in it.

This suggestive simplicity is a hallmark of Arnoldi as a poster artist – indeed as an artist on the whole. Right from the start, in the late sixties, he has tried to hone his idiom so that its message would emerge all the clearer. It looks easy, but it is not. Just as Andersen's language is the result of constant reworkings and ever-increasing precision, Arnoldi's idiom too should be seen as the continued refinement or tightening-up of its artistic effects.

"Less is more", people once said to characterize the development of Mies van der Rohe's architecture. This modernist dictum fits Arnoldi's endeavour like a glove, and that is just as it should

be, for he works very consciously and knowingly within the same tradition, as a late scion of the Utopian modernism that was formulated in the years up to World War II, and which in architecture found its purest expression in Mies van der Rohe and in painting in Piet Mondrian.

Both are in fact guiding lights in Arnoldi's universe. But before he arrived at a complete understanding of the richness of their rigorous, ascetic formal idiom, he took a detour by way of other figures – more light-hearted, more of their time. As already mentioned he started out in the 'swinging sixties' – when American Pop Art was new and inspiring and laid the foundations for a different, more relaxed approach to the visual than the tormented existentialism that had typified art in Denmark, as elsewhere in the first decade after the world war. Now it was once more permissible to use humour and to work with ironic distance in the picture – and this was a liberation, not least for a painter like Arnoldi, who was more blessed with both humour and irony than most.

That liberation can best be seen in his posters. The earliest are from the mid-1970s and are all typified by energy and exuberance. It seems highly fitting, but is perhaps a coincidence, that one of the first was done for a circus – Circus Arena, which also made use of Arnoldi's playful talent in other ways. It is from 1974 and shows a white clown who not only juggles with his own – *and* Arnoldi's – props, the bowler

hat and the candy stick, but also with the letters that say what it is all about. Everything is in play; everything is in the air.

Both the clown and his props are drawn with a wavy coiling line that unfolds organically over the surface until it fills it to bursting-point – without the draughtsman in any way losing control or the clown thus missing his catch. Everything is alive, but also in balance.

It is a magnificent debut in the genre. A zestful interpretation of the tradition. And yet a fresh departure. It is more than likely that Arnoldi had one eye on the wonderful poster that Ib Antoni drew in 1967 when the clown Charlie Rivel guested at the Circus Schumann. But in that case he did it in order to go off at a tangent from it. The real model in this phase is more likely to have been the scene painter Svend Johansen – and above all his anarchistic interpretation from the 1950s of various figures from the *commedia dell'arte* and the Molière-like Danish playwright Holberg. The same wavy line and the same rampant humour typifies Johansen's figurations – and the same feeling for the illusion that is the vital nerve of both the theatre and the circus.

2

Arnoldi's poster for Circus Arena toured the country for several years during the season – and thus made his style familiar to most people, although they could perhaps not yet put a name to it. But soon they would – the very next year he chugged straight into national consciousness with Danish Rail. This was with six posters set up in 1975 at all the Danish stations as part of a campaign that was to relaunch Danish Rail as the people's preferred mode of transport. And Arnoldi's solutions were so definitive that to some extent he has made all later attempts to do the same quite superfluous. This includes his own from the 25th anniversary in 2000, where the playful element from the first six has been replaced by a more intellectual, formalistic one.

The six posters from 1975 are arranged as a set that has the easy flow of the cartoon film. You read them off in a sequence and you are amused as you go. Without being directly naive, the formal idiom is as simple and direct as in a child's drawing. For example the posters are sky-high, but the trains chug away right at the bottom, undaunted and in all possible weather – in thunder and rain, in sun and snow, under the new moon and under the rainbow. And together they make up a journey through the flat land of Denmark of the kind we all know from the windows of the long succession of railway carriages for which we have bought tickets over the years.

Once more it is a proud tradition that Arnoldi renews – ever since the days of Hans Christian Andersen the railway has given rise to innumerable posters all over the world. The

international classic is the French master Adolphe Cassandre's futuristic poster for Nord Express from 1927; and the Danish one is Aage Rasmussen's more naturalistic poster for Danish Rail from 1937, known and loved by every child in Denmark. Both are dynamic in their idiom and are from a time when people still took an optimistic view of technological progress, and when the train was still the means of transport that carried most people safely from place to place and could link countries and continents.

All that was history in 1975, when air and bus traffic had long since sidelined rail traffic as the preferred form of transport. So Arnoldi could not pretend otherwise – he had to adopt another angle on the material and very aptly chose nostalgia.

Cassandre's locomotive is a streamlined modern machine that flashes past you with a presence and speed that hardly lets you perceive its details – and Rasmussen's diesel train comes thundering right at you out of the darkness with a drive that makes you involuntarily want to step aside, even though it is just a poster you are looking at. Arnoldi's little train, on the other hand, seems to go tumbling off through the landscape in high spirits, across the poster. It is far away, and there is no danger. On the contrary, it is obviously safe and comfortable inside the well-lit carriages.

It is a different time now, and our perception of time – as distance covered – has changed radically. Thus, when you take the train today, you are perpetuating a little piece of a world that once was, before time got out of joint and everything got out of hand. People who take the train arrive too – and arrive safely – if we are to believe Arnoldi and his six-panelled dream image.

For a dream image is just what it is. Those who take the train over the Great Belt Bridge can see for themselves that they have no trouble letting the motorists in on the road bridge see the back of them, just as it is common knowledge that you also normally arrive sooner at your destination if you sit in the train and not behind the wheel. What Arnoldi captures is thus not only the dream of a bygone age, but also the image that the Danes have of Denmark, as a charming little country where things are manageable and life can be lived securely and well.

Arnoldi is of course well aware that this is an idyllic image that only exists unquestioned in some Enid Blyton universe – but if it still appears pure and genuine in his posters, this is because, unlike Enid Blyton, he is able to give an account of it with a disarming ironic distance. He knows that things are different now – and we know it too as soon as we see his posters. The naive aspect of the presentation underscores the naiveté of holding on to the dream.

It is a trick that he learned from the American Pop Artists who depicted the consumer goods of the affluent society and the dream world of Hollywood with the same loving irony. So with some justification one can say that Arnoldi – along with Per Kirkeby – was the artist in Denmark who offered the most qualified response to the challenge inherent in Pop Art. Qualified – and original. For this is not a parroting of the style of others, but personal interpretations – in Arnoldi's case most clearly expressed in his posters.

Perhaps that is because the poster is a fast, popular medium, where the conveying of ideas is not only direct but also unpretentious, because the poster is not burdened with the aura of seriousness that weighs down original graphic art, painting and sculpture. Yet this does not mean that it necessarily ranks lower in the artistic hierarchies than the other media – by no means. Cassandre's posters, for example, are among the strongest visual statements in the European art of the period and the same is true – in Denmark – of posters by people like Thorvald Bindesbøll, Sven Brasch, Ib Andersen, Sikker Hansen and Arne Ungermann. This is the great tradition – and the tradition into which Arnoldi falls naturally as one of the most prominent figures.

He came to the poster as a painter, via Pop Art, cartoon films and scene painting, but at lightning speed he purged the idiom and turned it into his own – precisely because he was a

painter. As with Toulouse-Lautrec and Robert Rauschenberg, for Per Arnoldi too this is an output that exists side by side with his other artistic expression. Side by side – and on an equal footing, as an equally valuable statement; which perhaps has the advantage over the others that everything stands out more clearly – because everything must stand out clearly if the poster is to work as intended.

3

Fortunately there are many people – both in Denmark and abroad – who have taken notice of this distinctive talent of Arnoldi's for visual pith and potency. From the 1970s until today the commissions have come flooding in to him in quick succession. Almost washing over one another. Several hundred posters are the result – and even though certain sectors are more widely represented among the body of clients than others Arnoldi has by now been out into most corners of modern society. He has only left the Church alone – but then that isn't modern.

It can come as no surprise that so many have called on him when they had something to promote. For his posters have a quite special impact – you can *see* them, and they always stand out strikingly from others in the street scene, even when they are put up on pillars and walls along with scores of other loudly proclamatory examples of the genre. They are

authoritative – and you are never in any doubt about who made them. Irrespective of what they advertise – a play, an exhibition or a jazz festival, a house painter, an architect or an American president – you recognize the style long before you read the message.

This immediate recognizability is due to the consistency that Arnoldi has shown throughout his career in the trade – the distinctive visual economy he has imposed upon himself from the start. The exercise has been to limit the colour scale to the least possible and otherwise stick to the same typography all the way through. Clearly there are variations within the scale, but they are few and inconspicuous, and always generated by the situation. Now and then, for example, his posters may be dominated by green, black or grey – but only when the theme so demands. Green stands for nature and black and grey for seriousness, and sometimes the typography can vary a little too – but only when the client requires it. After all, the newspaper *Politiken* cannot change its characteristic lettering just for Arnoldi's sake.

Arnoldi's signal colours are blue, red and yellow, and his preferred font is Futura. And he has stuck to this right from the start – a splendid example is the poster he made in 1975 for the wine company Det Franske Vinlager. The yellow and blue colours define the white glass, and the red tells us what kind of wine is in it. It is simple to the point of banality

– but Arnoldi would not be Arnoldi if imperceptible shifts in the interrelationships of the three colours did not also tell us that this is not the first glass of red wine that has been imbibed. There is something dance-like about the figuration, as if testifying to a slight tipsiness – and thus to the joys of the wine merchant's products. As will be evident, Arnoldi at that time signed his posters – but he no longer needs to. The style has long since become synonymous with the man.

There is something almost abstract about the composition – something clear and pure that tells us how Arnoldi is attracted to the above-mentioned Utopian modernism of the first third of the twentieth century. In fact he has borrowed the three colours he has chosen as his own from Mondrian, who in the course of his career reduced his scale to exactly these: blue, red and yellow. This was a kind of asceticism to which he subjected himself, a kind of visual Pietism that permitted him to purge the picture surface of all superfluous material. The three primary colours appear in Mondrian's work on white backgrounds, clamped into a rigorous black latticework that divides the surface into rectangles and squares of ever-varying size. The seriousness is striking – and the tension that arises among the three colours in the latticework almost takes on a metaphysical character. We are not far from the whitewashed Dutch church interiors of the Reformation period, or for that matter from a painter like Vermeer.

Arnoldi's seriousness does not have the same metaphysical character – he is a declared atheist and perhaps inclines more to the view that his posters have a moral function, and that with their fine-honed beauty they can have an enlightening effect on the mind and thus set a standard amidst the visual overabundance of shoddy vulgarity to which we are increasingly exposed in the west. And in the actual situation a poster for a French wine house is in his view just as important as one that warns against the spread of AIDS.

4

The themes suggest the wide range of Arnoldi's production of posters – from the commercial to the ideal. But it is characteristic that at all times he gives it his best shot. Once he has accepted a task he applies his whole talent to a solution, regardless of the nature of the subject, whether it is a French claret for Danish palates or clean water for the developing countries. But clearly the intensity is greatest when it is subjects like the latter that are to be put on the poster. In this case mildly humorous diversions will not do – it is the cause that has to be promoted, and the style is there only as the vehicle.

When one browses through the book it will be evident that Arnoldi has dealt with many tasks of this edifying kind – and that his solutions are absolutely among the strongest in his output. The seriousness of the theme has in every case brought out the best in him.

An early example is the series of four he did in 1978 for the Ministry of Energy – for a campaign that was to get the Danes to turn down the burners, to save a little on petrol, power, heat and water. They are drawn in the softly curving style that was also characteristic of the poster for Circus Arena, but, typically, it has now been greatly tightened up. The form and the message are clearer to see – although the humour is still telling. The word "Spar" ("Save") is thus incorporated as a luxuriantly spreading element of the picture itself, in every single case visualizing what is to be saved or limited: the hot water, the black exhaust smoke, the dazzling electric light.

However, the humorous and the luxuriant disappear with the years, to be replaced by a more ascetic or minimalist idiom where the subject is transfixed by a single, highly symbolically charged sign of an ambivalent nature. The statement is screwed to the sticking point and all superfluity is peeled away. The symbol stands forth clearly and authoritatively so that the message cannot be misunderstood.

The poster for clean water has already been mentioned. It is from 1998, and was done for the church aid organization Folkekirkens Nødhjælp – and it shows in all its simplicity a slightly crooked question mark that stands quivering gently

against a blood-red background. The question mark is black at the top, but blue at the bottom – or to put it differently, it is impure at the top but pure at the bottom, where it furthermore, thanks to the drop-like shape of the dot, takes on the character of the illness-preventing water tap to which so many people still do not have access in the developing countries.

The statement is both simple and sophisticated, and there is no mistaking it – it is moreover extremely characteristic of Arnoldi's approach to the material in recent years. In 1988, when he was to make a poster for the campaign against AIDS, he made use of the same informative simplicity. In this case it is a red heart that stands slightly quivering on a blue ground; but the heart, the very symbol of love, is upside down, so that it suddenly recalls a drop of blood, and thus one of the vectors that can carry the fatal virus from one person to another. The heart of the matter captured in a single stroke: love – sex – the risk of infection. So beautifully and disturbingly can it be done.

The same supreme simplicity is exhibited by the poster "Save the Alps" – which Arnoldi drew in 1993 for anxious international clients. For the heaven-aspiring snow-clad peaks of the Alps are in fact being worn down to the bare rock and depleted of life by air pollution and the tourist trade. It is not something we think about on a daily basis – on the contrary the mountain range has stood since the Romantic era as the

very symbol of the indomitable magnificence of nature, at once awesome and compelling. In that era painters like Turner and Caspar David Friedrich depicted the mountains in their mighty sublimity and always underscored the smallness of mankind in relation to them. They knew nothing of acid rain and skiing tourism.

But Arnoldi knows – and although his Alpine peak is a beautiful continuation of the Romantic tradition, as it strives upward into the blue firmament, this is a thought-provoking denial of the very same tradition. The Alps are neither untouchable nor indomitable – up there too, in the thin air among the peaks, man intervenes destructively. Stupidity and profiteering know no bounds. So how does one express this depressing fact? By putting a large, all-encompassing fingerprint in the no longer so eternal snows. Another classic of the series!

The same is true of the poster that commemorates the escape of the Danish Jews across the Sound to Sweden in October 1943. It was designed for the fiftieth anniversary of one of the few events we Danes can remember with a certain pride from the Occupation years – and Arnoldi fully rose to the situation. As in the case of *The Ugly Duckling* the surface is divided up into two equally large blue fields, sky and sea – and the 'way to go' is suggested by the infamous yellow Jewish star; which is not drawn quite by the book, but stretches upward and

outward towards the horizon and the Swedish coast. It stands there like an admonitory barrier at the bottom of the picture, but it also opens up into the space like a hope of salvation. The symbolism is as simple as it is definitive.

When the subject so requires, when it all becomes too serious for colour, Arnoldi imposes further constraints on himself and dispenses with blue, red and yellow so he can let the black predominate, the colour of darkness and death. And here too he hits the mark perfectly; for example in the posters for the national associations for the mentally ill and Alzheimer sufferers. These are two relentless illnesses that can strike anyone, and which are a burden not only on the sufferers who are struck down by them, but also for their loved ones. In this case it will not do to splash out with the colours. In this case the darkness prevails.

Arnoldi's solutions are both touching and frightening. The mentally ill are symbolized by an anonymous profile cut from paper with the same precision as Hans Christian Andersen could mobilize when he sat with the scissors in his large hands. Nose, mouth and receding chin – and then a small expressionless eye. That is all – or almost all. For Arnoldi has crinkled the part where the brain is with a firm, brutal twist that not only suggests where things have gone wrong, but also how difficult it is to straighten it out again. Even a smoothing-iron would have to give up. There will always be traces left.

When it comes to Alzheimer's, he reduces the expression even further – well aware that in this case all hope has gone. No pictures, no symbols – only letters. On the other hand they make their point clear. Or rather increasingly unclear. The name of the disorder is written right across the poster, from light to darkness, from the whitest white to the darkest grey. Just as the illness makes the mind disintegrate and the memory fade away, the very name of the curse vanishes from sight. Arnoldi has also designed the association's logo and has inserted it like a tragic accent below – a blood-red, but totally cracked A.

When UNHCR – the United Nations High Commissioner for Refugees – asked Arnoldi in 1999 to make a poster for the benefit of the refugees from Kosovo, he made use of the same technique. Again it is the letters and the words that speak volumes. HOME, FAMILY, HEALTH, HOPE, FUTURE, it says, in black type against a background of something that – very appropriately – looks like recycled paper. But the first four words are torn across, as if they have been crossed out. They represent the past of the refugees, everything they have lost; all they have left now is the future. And it does not look bright, as Arnoldi has suggested figuratively by folding up the bottom right-hand corner of the poster –a 'reminder' that sponsors with their hearts in the right place can now show what they are made of. Something that has to be remembered!

5

"Art is communication is art...", writes Arnoldi at the front of the book, like a kind of mantra for his work with the posters. The dots suggest that one could in fact continue the statement *ad infinitum*. As he himself has done, with a flood of posters that by all indications will not dry up any time soon. Art is communicating – with others – and telling them something that they perhaps know already, but have forgotten in the rush. And telling it in a way that leaves them in no doubt about the truth of what is communicated. Communication is art – or rather it can be if you mean well to your fellow human beings and know how to express it precisely. Like Arnoldi.

For this kind of artistic informative work demands not only a high proportion of idealism, but also perspicuity, intelligence and poetry. Arnoldi has himself made a poster that beautifully states the requirements. "Communication", it is called, and was designed for the German Poster Museum in Essen in 1994. What it shows is that the best path from A to B is not necessarily the straight one – it can be necessary to digress to reach the goal. It can be necessary to flutter like the butterfly around the subject until it is clear what it is really all about. Only then can you settle and flap your radiantly coloured wings a little in the sunshine. But only a little – for there is still a new stretch to put behind you, from B to C and from C to D and from ... etc.

Yes, there is so much to be communicated in a globalized world like the one we live in today. The confusion is overwhelming and endless. For the same reason it is urgently necessary that there is someone who takes care of letting the truth pierce through the tissue of lies that is spread via the media, and through the filter of irony and irresponsibility that is at present obscuring our view of reality.

As an artist you can do it by painting troublesome pictures that insist on unfashionable ideas – or by shaping sculptures so they stand in the way of glib thinking. And then you can also do it by making posters as Arnoldi does – posters that are beautiful in their form and clear in their thinking. Posters that have much more on their minds than one normally finds in the genre, and which communicate knowledgeably and intelligently with anyone who still has eyes to see and a few grey cells behind those eyes.

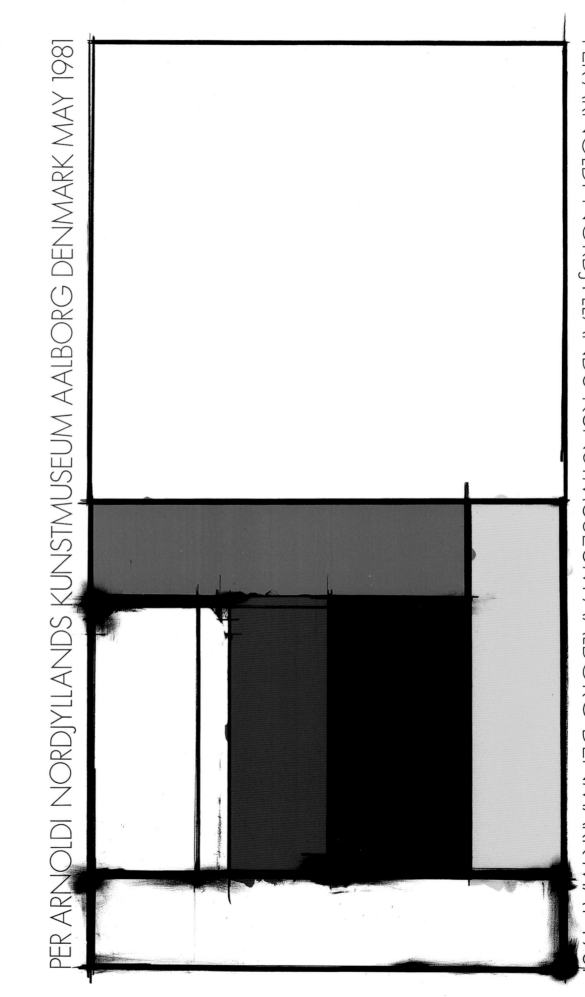

PER ARNOLDI NORDJYLLANDS KUNSTMUSEUM AALBORG DENMARK MAY 1981

PER ARNOLDI NORDJYLLANDS KUNSTMUSEUM AALBORG DENMARK MAY 1981

PER ARNOLDI NORDJYLLANDS KUNSTMUSEUM AALBORG DENMARK MAY 1981

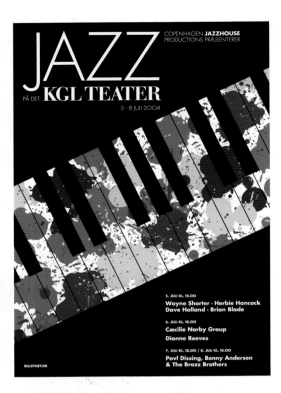

JAZZ AT THE ROYAL THEATRE COPENHAGEN

POSTER <

2004

COPENHAGEN JAZZ FESTIVAL 25TH ANNIVERSARY

POSTER >

100 x 70 CM

2003

" Now and then you have to just take the plunge and go for the first, worst cliché that pops up when you have to tell a client's story. Jazz has a couple of pervasive clichés that are flogged to death again and again, and if you're afraid of them you have to keep your pencil well away from jazz posters ... The saxophone is one of them, so overblown and twisted out of shape that there are hardly any other possibilities – apart of course from the infinite number of meaningful and meaning-bearing variations that are straightforward enough if you take the bit or the mouthpiece or whatever between your teeth ...

So for the 25th anniversary poster for the Copenhagen Jazz Festival I had to somehow celebrate 25 years of poster clichés and the 25 years of music along with the many helping hands, and the heroic fingerprints of the staff of the institution who have ensured its very survival. The motley throng of fingerprints up and down and around the sober contour of the soprano sax was one possibility among all the others that will keep popping up as long as this immortal music sounds and survives ..."

COPENHAGEN **JAZZ** FESTIVAL

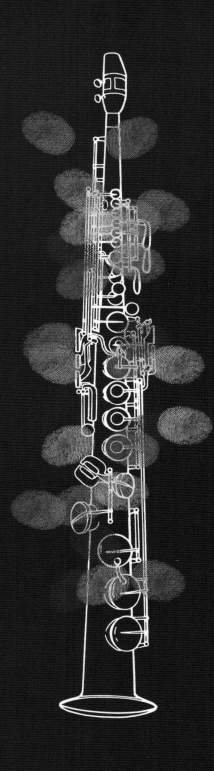

www.jazzfestival.dk

1979

JULY 4-13 2003

ALFRED BENZON

LOGO FOR SYMPOSIUM ∧
1999

ABSOLUT ALPS

POSTER FOR >
ABSOLUT VODKA AND ALP ACTION
120 x 80 CM
1991

"To mark the World Economic Forum's annual meeting high up among the summits of the Alps in the Swiss ski resort of Davos, Newsweek International published a special issue in cooperation with, and in support of, the organization Alp Action's work for the protection of the fragile, greatly endangered Alpine landscape.
Absolut Vodka was one of the advertisers in this special issue that supported the cause and raised its international visibility. I was asked to design a poster and advertisement. Within the quite transparent graphic framework of the quite transparent bottle, and for a firm that over the years had created one of the best image campaigns in the world, I was to draw attention to vodka, Alps and action. I had to provide a spirited formulation of the need to keep the endangered snow of these perfect summits as clean and their water as clear and their valleys as green as at all possible – and whatever else followed from that, all the way down and well out into all the surrounding, highly diversified, beautifully balanced eco-systems etc., etc. ...
So: an icon within an icon ... a spirit in a bottle ... Absolut Alps!"

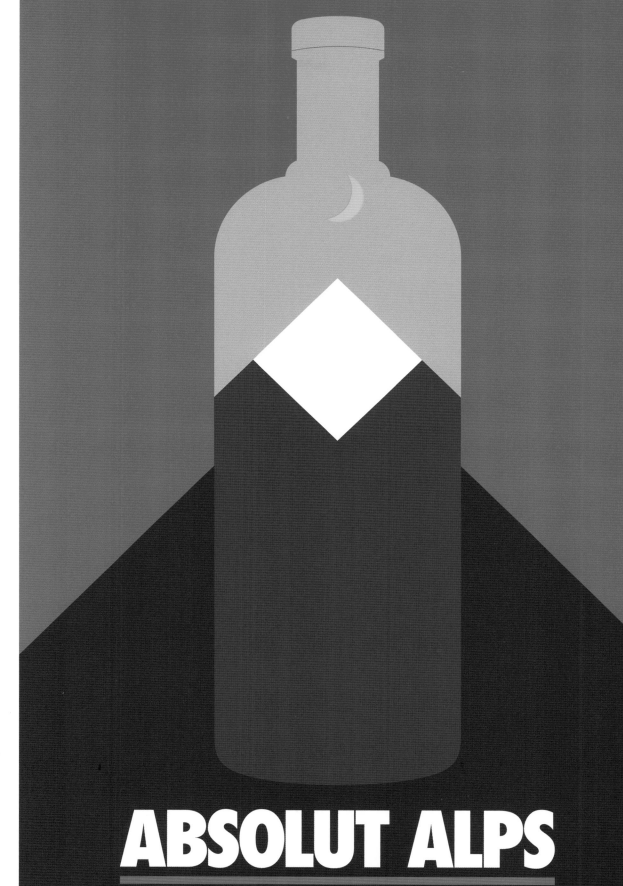

DENMARK AMERICA FOUNDATION

LOGO /\
1994

AIDS AVOID INFECTION

POSTER FOR MINERVA FILM A/S >
120 x 80 CM
1988

" You can't go wrong if you follow your heart!

It signifies love, and the interpretation can presumably also be extended to everything that goes with love and the consummation of love, and thus to sex – so it was very relevant as a symbol in the uncertain world from which the first reports of AIDS came. My thinking was this: if a traffic sign meant one thing and the same sign upside down meant the opposite, or at least that you had to take care, then the heart, viewed as a traffic sign, could mean 'Take care, love or sex ahead!' Which wouldn't be so bad ... and then a heart upside down could by the same 'logic' mean 'Take care, unsafe sex ahead!'

So that's what I used for a poster and a campaign for an informative / cautionary school film about AIDS in 1988.

There was nothing wrong with the visibility and the attention it aroused ... but I hadn't foreseen that gays would see another body part in the soft curves of the upside-down heart and feel offended and protest loudly. But the thing is that we're all affected by this, and if it's to make a serious impact, any graphic message that turns out to have the required and desired effect and force must necessarily hit both more and less sensitive targets. So one's graphic precision bombardment can't be that precise after all, and – not to put too fine a point on it – when the campaign is about AIDS, you need to spread your shot!"

AIDS

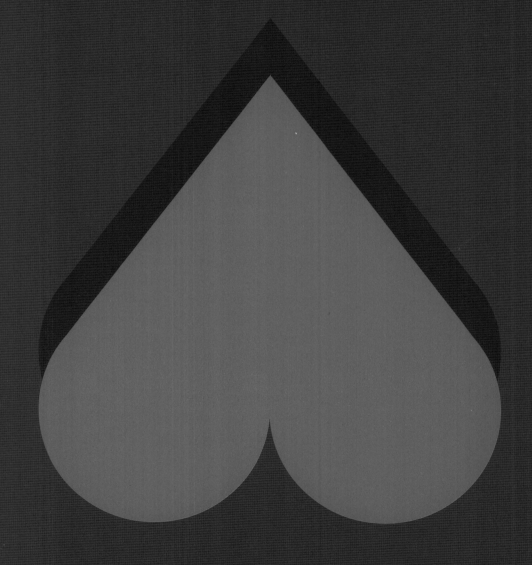

UNDGÅ SMITTE

SKETCH

2000 ∧

ARTE

POSTER >
100 x 70 CM
1986

 "Laugh or cry? The Arte poster from 1986 is yet another variation on the long-suffering theatre masks, this time in profile. Comedy or tragedy seen from and along the spectator rows or rather all the halls that the powerful theatre ticket and subscription agency has filled over many years. Art for the people or people flocking to art – in there, down there in the magic dark of the hall, illuminated and enlightened from the stage. Cry or laugh, now that the organization has conquered and died? ... But that was the Arte that was ... and the theatre itself didn't die of it!"

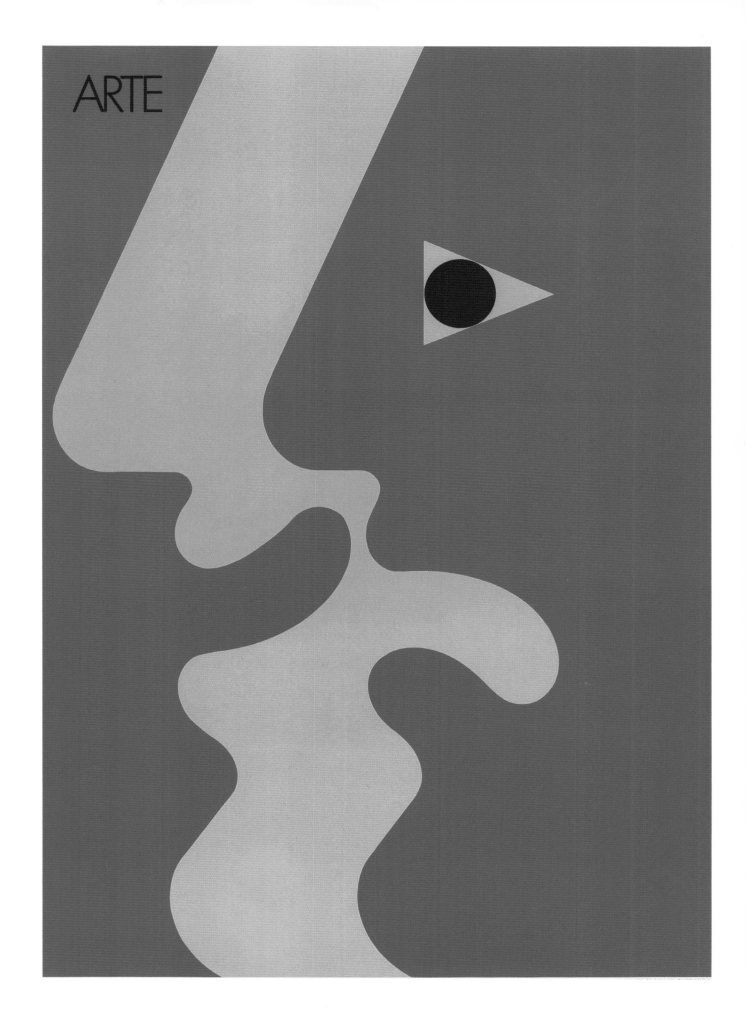

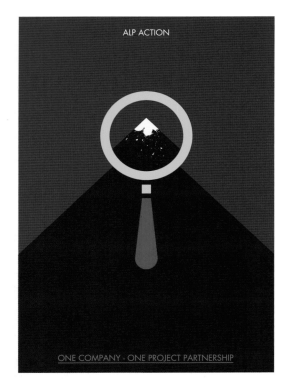

ALP ACTION

ONE COMPANY · ONE PROJECT PARTNERSHIP

SAVE THE ALPS

POSTERS FOR ALP ACTION GENEVA
AND NEWSWEEK INTERNATIONAL
100 x 70 CM
1993 >
1995 <

" Alp Action is an organization that tries heroically to
anticipate, prevent and remedy man-made damage and wear
on the fragile landscape of the Alps.
The mountains may look massively robust ... but the traffic
and our own relentless tramping are also massive and
our airborne fingerprints so corrosive that the forces for good
have to be mobilized.
And so – Alp Action and the fingerprint's micro-image of a
macro-problem in the white snow."

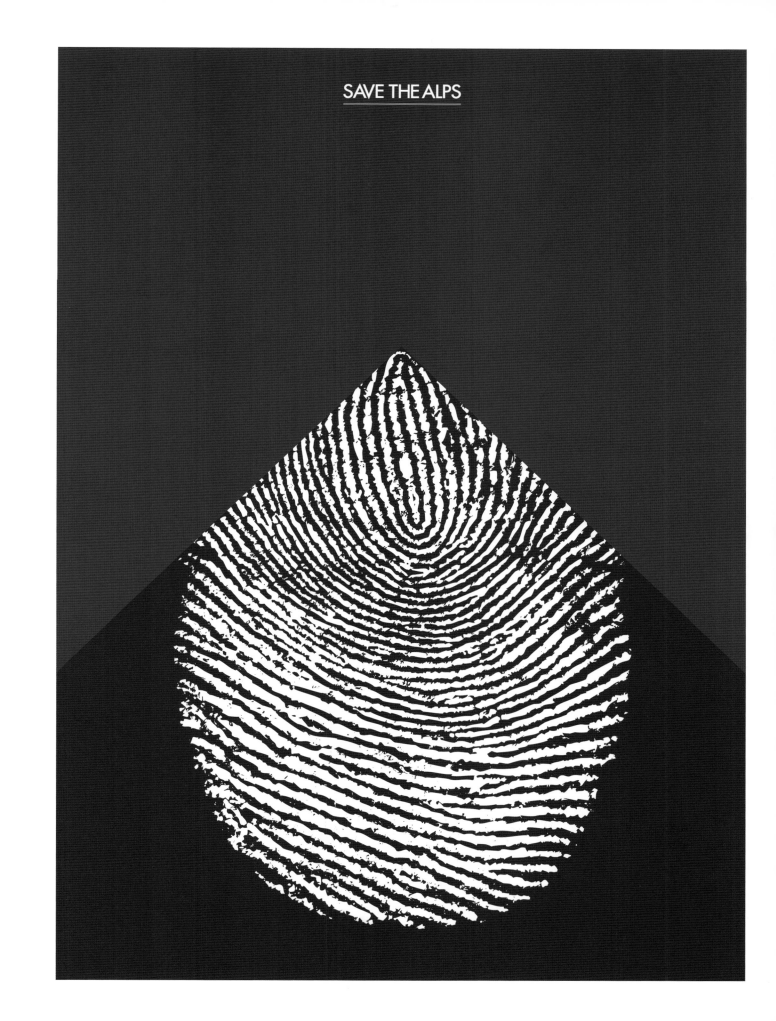

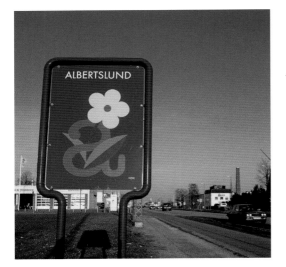

ALBERTSLUND TOWN OF THE YEAR

LOGO <
1995

AIDS

POSTER FOR AIDS FOUNDATION DENMARK >
100 x 70 CM
1988

" It's probably inevitable. AIDS posters and campaigns, I suppose, have so much built-in controversial dynamite that they can explode before they reach the public they are aimed at.

I gave a draft of a poster to the WHO in Geneva, where some of the first concerted efforts to inform people about the ticking bomb of the AIDS epidemic were concentrated. The campaign's optimistic slogan, *A worldwide effort will stop it*, was given from the start. My motif played very simply on this statement: a 'worldwide' ring of hearts, strung like a necklace, was the peaceful symbol of cooperation and solidarity all over the globe and at the same time a gentle image of the terrible nature of this epidemic ... that it was associated with love or at least sexual contact between people.

And beneath all the gentleness, of course also the fact that a cycle of infection is an unending circle or chain. Despite the threatening character of the subject I saw no reason to turn an informative campaign into a campaign with a scarier image.

The poster was approved, but never printed, because the whole row exploded: a mixture of representatives of countries that denied the existence of AIDS and thought you could kill off the epidemic with a conspiracy of silence, and religious moralists who ranted about punishment and sin, unanimously condemned the poster as a promotion of promiscuity. 'Sleeping around' was the expression used to reject it, and the behaviour they thought I was out to promote. So it died the death – until we printed it for the AIDS Foundation in Denmark, which fortunately thought that relevant information was more important than moral over-interpretations and panic rejections. And after all 'sleeping around' was what it was all about anyway!"

AIDS

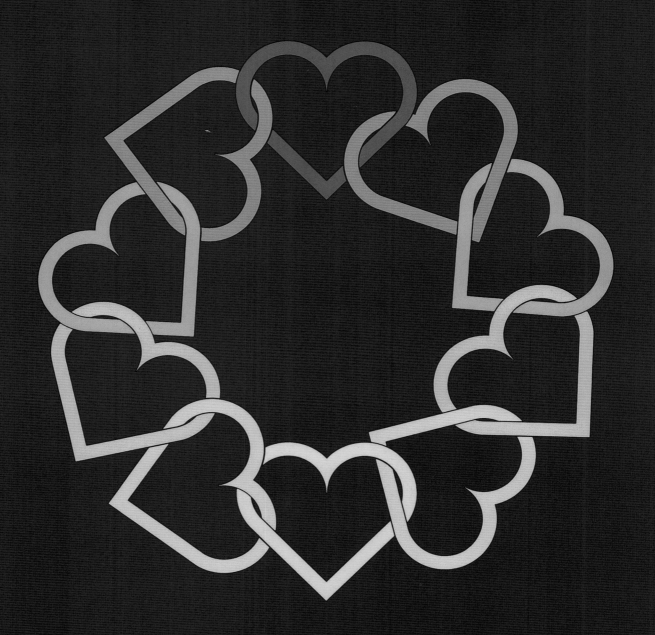

A WORLDWIDE EFFORT WILL STOP IT

AIDS FONDET GIRO 5 90 92 60 INFORMATION FORSKNING PATIENTSTØTTE 1988-89

THE ALZHEIMER ASSOCIATION

LOGO ∧
1993

POSTER >
100 x 70 CM
2000

" What is one to do? It could hardly be more tragic.
Again, as the logo for the newly founded Alzheimer Association,
a letter, a little, round, harmonious and friendly Helvetica 'a'.
And the irrevocably terrible has happened ... an 'a' torn in
pieces, no longer a whole letter ... no longer a whole human
being and yet an interpretable image of the lost identity.
And then a later poster's elementary narrative of the fearsome
course of the disease ... into the darkness."

alzheimer

DANISH FEDERATION OF ART GALLERIES

LOGO ∧
1993

ALGONQUIN HOTEL NEW YORK

POSTER • >
100 x 70 CM
2002

" The myth is massive. I think the myth of the Algonquin Hotel's round table is better known than the myth of King Arthur's. At all events it's so much closer to us – the twenties and the thirties when legendary legends worked their way steadily through a true desert of highly forbidden and very dry martinis and well-turned, well-publicized witticisms and criticisms around the round table in the dark lobby. They were well aware of what they were doing in the early evening and what publicity was ... for it was their job.

No quotation was left unturned. They are long gone, but the myth endures and still attracts people from the business.

It's as if the very name The Algonquin has earned its own seat at the high table of tall tales."

ROBERT BENCHLEY
GEORGE S. KAUFMAN
FRANKLIN P. ADAMS
BEATRICE KAUFMAN
HEYWOOD BROUN
DOROTHY PARKER
HARPO MARX
EDNA FERBER

THE
ALGONQUIN
HOTEL

**COPENHAGEN CULTURE
SOCIAL SUMMIT**

LOGO ∧
1995

**AMERICAN BALLET THEATRE
50TH ANNIVERSARY**

POSTER >
100 x 70 CM
1990

" American Ballet Theatre celebrates
50 years as a thoroughly modern
ballet company ... and although the pointe-
working leg is still, like the jazz saxophone,
a persistently pointed symbol of the ballet,
here too it was necessary, despite the round
number of years, to insist on the modern, so
it would be clear that the company wasn't
modern in name only!
I tried to delay the immediate recognition
and the familiar symbol and make the
pointed toe trace both a clear and a teasingly
'unclear' shape out of the preposterously
posterish colours.
It takes a second before you see it dance."

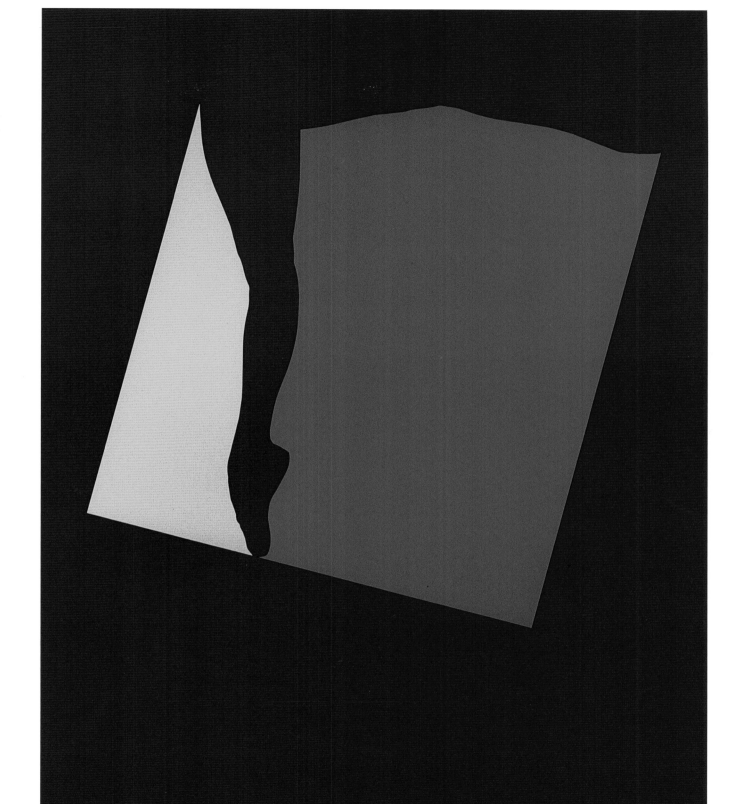

1940 1990

AMERICAN BALLET THEATRE

**DANISH AUTOMOBILE
DEALERS' ASSOCIATION D.A.F.**

LOGO ∧
1995

VIGNETTES FOR D.A.F. ∨
1995 / 2002

AMERICAN DANCE FESTIVAL

POSTER >
100 x 70 CM
1985

" I had just finished the work on costumes and sets for a George Gershwin ballet for the Atlanta Ballet; and from the world of the ballet and the thirties, where I had really felt rather comfortable, I had to advance right up to the foremost front line of modern dance in a poster for the American Dance Festival, held every summer in Durham, North Carolina.

I took the leap towards a combination of the old dancing-school foxtrot diagrams on very thin paper for home use, to get right down and far away from the pointe-work pictures, and on to the hands as the tools of mime and ancient simple impressions in cave paintings and other 'primitive' art ..."

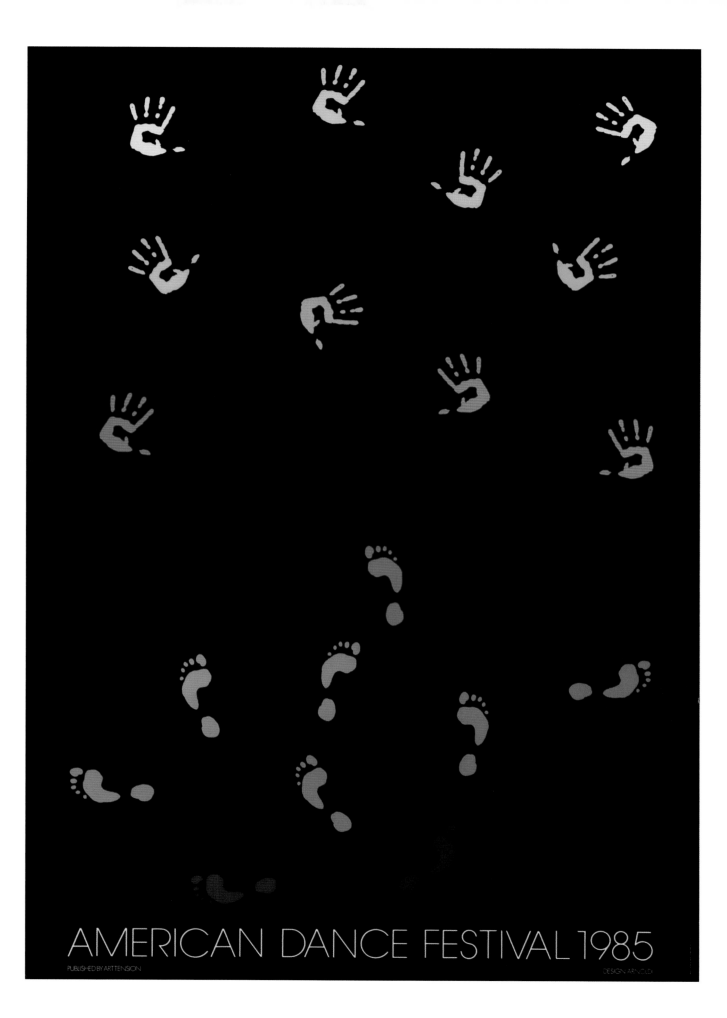

AMERICAN DANCE FESTIVAL 1985

PUBLISHED BY ART TENSION

DESIGN ARNOLDI

LANDSCAPE GARDENERS

LOGO ∧
1990

AIDS

POSTER FOR AIDS INFO FUNEN >
10TH ANNIVERSARY
100 x 70 CM
1995

" The thing about posters and
campaigns for AIDS, or rather
information and warnings about AIDS, is
that it's hard to know whether you should
speak quietly and urgently or loudly and
threateningly – gently warning or wildly
frightening.
Or whether you can find a visual idiom that
does both at once. I tried the latter with
the lovely peaceful water surface which is
perhaps, once in a dreadful while, broken
by the ominous fin of the shark ... I mean
everyone likes to swim, but ..."

AIDS

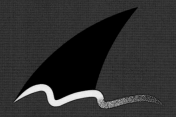

DAHL CONSULT

LOGO ∧
1994

**THE AMERICAN JAZZ ORCHESTRA
NEW YORK**

POSTER >
100 x 70 CM
1990

" Don't knock the image that's pure serendipity and the quite obvious solution. There's a bonus in the banal too! Art and clarity of form don't arise from the arty or artful, although it might sound as if they do. The logo for Dahl Consult shows the man and what his firm does: advises on trade between Denmark and Japan. So when the two marvellously round letters which *I* didn't choose fall into place by themselves in a little two-tone symbol that can into the bargain read from west to east, there's no reason to look any further."

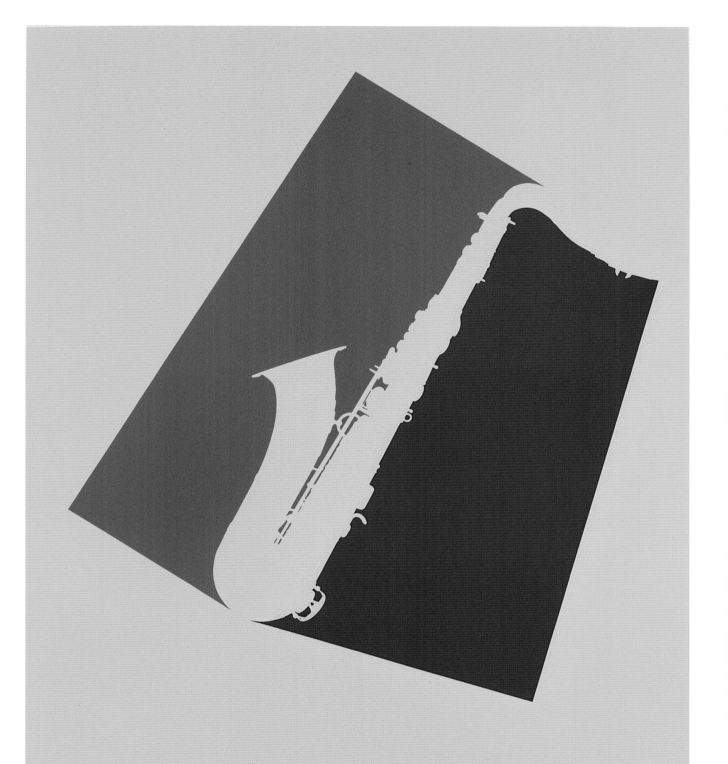

THE
AMERICAN JAZZ ORCHESTRA

MUSIC DIRECTOR & CONDUCTOR JOHN LEWIS

100 JAHRE FRISCHE

LOGO FOR FISH WHOLESALER HAMBURG ∧
1991

NEOCON 21 CHICAGO

POSTER >
80 x 60 CM
1989

" A press conference in Hamburg was supposed to
quash rumours of 'unfresh fish' in the German shops and
convince a shoal of reporters otherwise.
I was asked to design a little humorous logo for the occasion
that would add to the general optimism.
Not wanting to be pinned down to any hook or species,
I designed my own ... with a fresh little wink at Picasso!"

MODULEX DK

LOGO ∧
1988

AMERICA TODAY 500 YEARS LATER

POSTER FOR SECOND INTERNATIONAL >
BIENNIAL OF THE POSTER MEXICO
90 x 60 CM
1992

❝❝ The whole western world may have been celebrating the 500th anniversary of Columbus' discovery of America, but the mood and strongly expressed view among the participants in the graphics workshop I had been invited to supervise in Mexico City for young professional designers, arranged by the Mexican Biennial of the Poster, was quite different.

The results of the Mexican workshop were to be included in an exhibition where a number of old hands were to arm-wrestle with the young and with one another, and in particular with the common theme: America Today – 500 Years Later!

Jubilee or genocide? Triumphalist imperialism or a festive historic commemoration?

The opinions were as divided and divisive as the north-south border that most of my Mexican participants experienced as criss-crossing and fouling the east-west motif the organizers had perhaps intended ... The feeling was infectious ... now and then it's the teacher who learns most!"

AMERICA TODAY 500 YEARS LATER

ART OMI NEW YORK

LOGO • ∧
1992

AMNESTY INTERNATIONAL

POSTER >
80 x 60 CM
1998

" The poster doesn't have so many possibilities and elements at its disposal.

By its very nature it has to be directly and quickly readable with no beating about the bush or explanations. So the few statements you can make, and the very few simple elements your statement can deploy and consist of, must be honed to the finest point to cut through the chaos that may make up the poster's surroundings and everyday conditions.

In this poster for Amnesty International a single image had to combine the absolutely confined with the most infinite outdoor freedom ... the hopeless dark of the cell with the highest blue heaven ... inside in despair, and outside where this organization wages its battle."

AMNESTY INTERNATIONAL KØRER FOR MENNESKERETTIGHEDERNE
LANDSDÆKKENDE CYKELLØB **SØNDAG 30. AUGUST 1998**

BANG & OLUFSEN

LOGO FOR ∧
BAUHAUS ARCHIVE EXHIBITION BERLIN
1985

POSTER FOR B&O SPEAKERS >
80 x 60 CM
1989

> " For the launch of a new wall-hung speaker B&O needed a poster. The front of the flat speaker was divided up like a slightly elementary Mondrian into four fields in different materials, cloth and metal. The fact that it hung on the wall and 'functioned' as a picture, or rather as two stereophonic pictures, made it tempting to exaggerate precisely this aspect of the matter. Sometimes the choice is between emphasizing and playing down ... so in this case I let the discreet B&O's tasteful partitioning and appearance go amok and explode in the more dynamic picture, which maybe – hopefully – made such a visual noise that the impossible had succeeded: making a picture of sound ..."

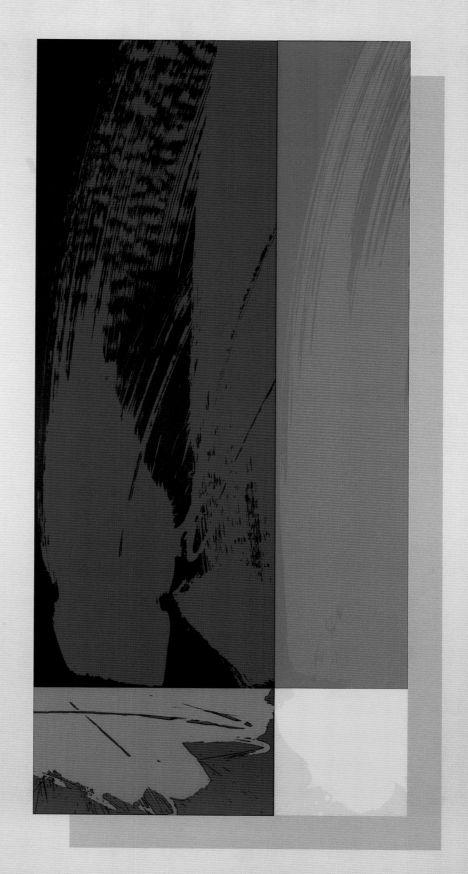

BB SERIGRAFI & OFFSET

LOGO ∧
1994

POSTER FOR >
BB SERIGRAFI & OFFSET 25TH ANNIVERSARY
175 x 119 CM
1994

" Shades of Magritte!
His amazingly effective and simple devices have pulled the carpet from under our whole view, reading and understanding of the word/image relationship.
The picture of a pipe with the text 'This is not a pipe' is the best known example.
But his night pictures, where the black silhouettes of houses and trees are disturbingly contoured against a daylight sky, are unbelievable too. Yes, unbelievable is the right word ... for what are we to believe: is it day or night? The eye contradicts the brain! And when is a wall in a closed room with cloud formations outdoors or indoors, nature or non-nature?
BB is a big solid printing house specializing in those very images and billboards that make holes in the sky above us and everywhere.
So without being particularly profound, their anniversary poster is a poster within the poster, a tribute to Magritte who made it difficult to see clearly..."

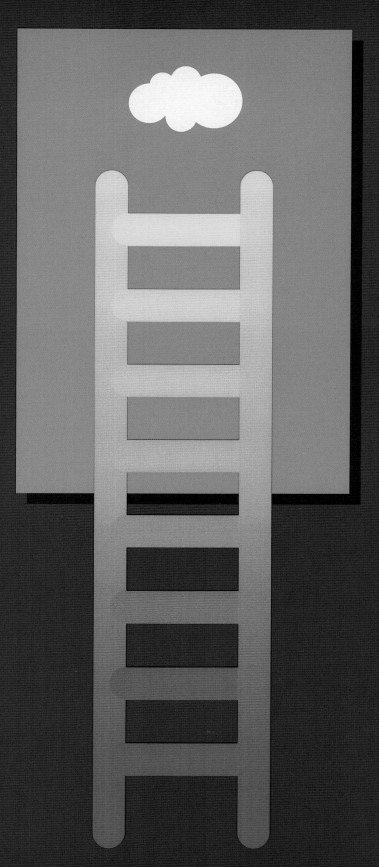

BBSERIGRAFI 25 ÅR · TEGNET AF ARNOLDI 1994

DISCOVER DENMARK

LOGO FOR /\
DANISH MUSIC INFORMATION CENTRE
2002

CONFETTI

POSTER FOR CAFÉ / BAR BIRKERØD >
100 x 70 CM
1985

"The restaurant Confetti on Madison Avenue in New York was somewhere I would eat lunch. At the same time couldn't help chewing over how a poster for a restaurant called Confetti might look if I was ever asked, because the place was decorated with Lautrec posters grouped around his whirling Confetti poster. Birkerød isn't New York. But Confetti is Confetti, and a café opened there in 1985. The job was to design a logo poster with confetti that could at the same time decorate the walls of the café and scatter a few stray colour accents over room, napkins, menu, awnings, windows, guests and staff.
The small dots are fine for this. They can appear alone or in small clusters, like the last spot of colour behind a chair six months after the last confetti bomb has gone off on New Year's Eve.
Individually, too, they send out a little radiantly coloured signal: Confetti."

CONFETTI

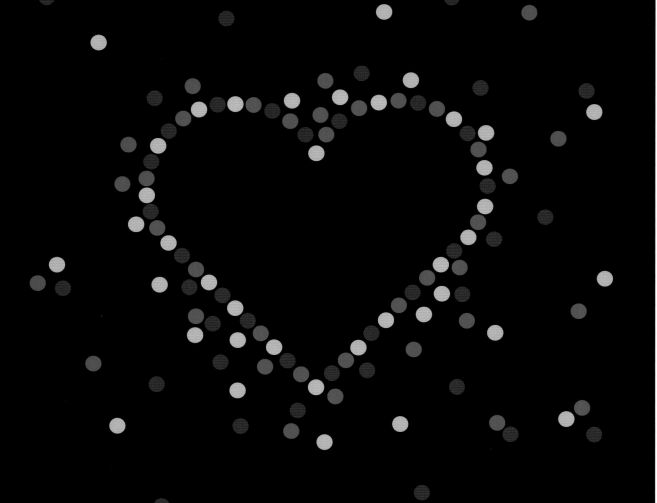

CAFÉ/BAR BIRKERØD HOVEDGADE

DOCTORS' DAYS

LOGO ∧

2000

CHILDREN'S CANCER FOUNDATION

POSTER >

100 x 70 CM

2000

" Whatever you do, the subject is heart-breaking. The bright yellow ground isn't meant to cast any smiley light over anything. But the research involved, which in this case is pleading for help and support, can presumably only keep up its spirits with the hope of some success."

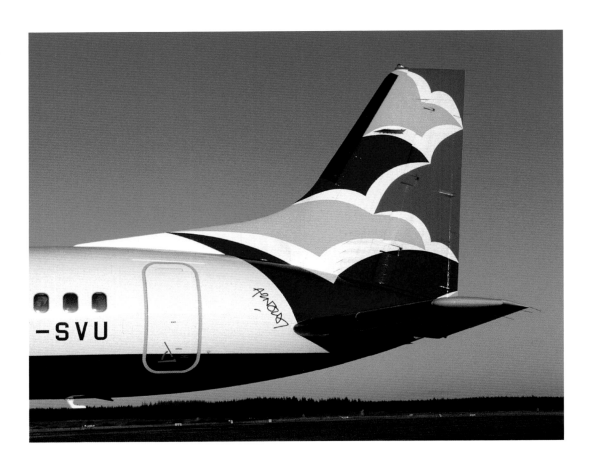

BRITISH AIRWAYS

1998 ∧

POSTER >
120 x 100 CM
1998

"A very short version of a very long and instructive story!

British Airways decided to abandon its 'imperial' image with Rolls-Royce engines, Union Jack and coat of arms in favour of planes painted with a whole series of ethnic motifs from the places around the world covered by 'the World's Airline'. That meant a Chinese calligraphic symbol from Hong Kong, an aboriginal motif from the Australian bush … and then of course a really ethnic Danish motif, etc. etc. But the problems quickly appeared. What was ethnically correct? And what was comprehensible; and when did one get the point about 'the World's Airline'?

As long a fleet of model planes, in all their motley multiplicity, were standing row on row in the presentation – and later, in real life, all together at Heathrow Airport – the signal was clear enough.

But when a single plane is on the runway in Bangkok, it becomes lonely and misunderstood. The idea was pure theory.

And, interestingly, the theory took a dive as far as the public was concerned, who refused to fly with these individually unrecognizable aircraft.

Halfway through the process of painting all the planes and vans and posters and uniforms with all these different symbols the idea was given up. What should have been re-branding became de-branding, if there's anything called that."

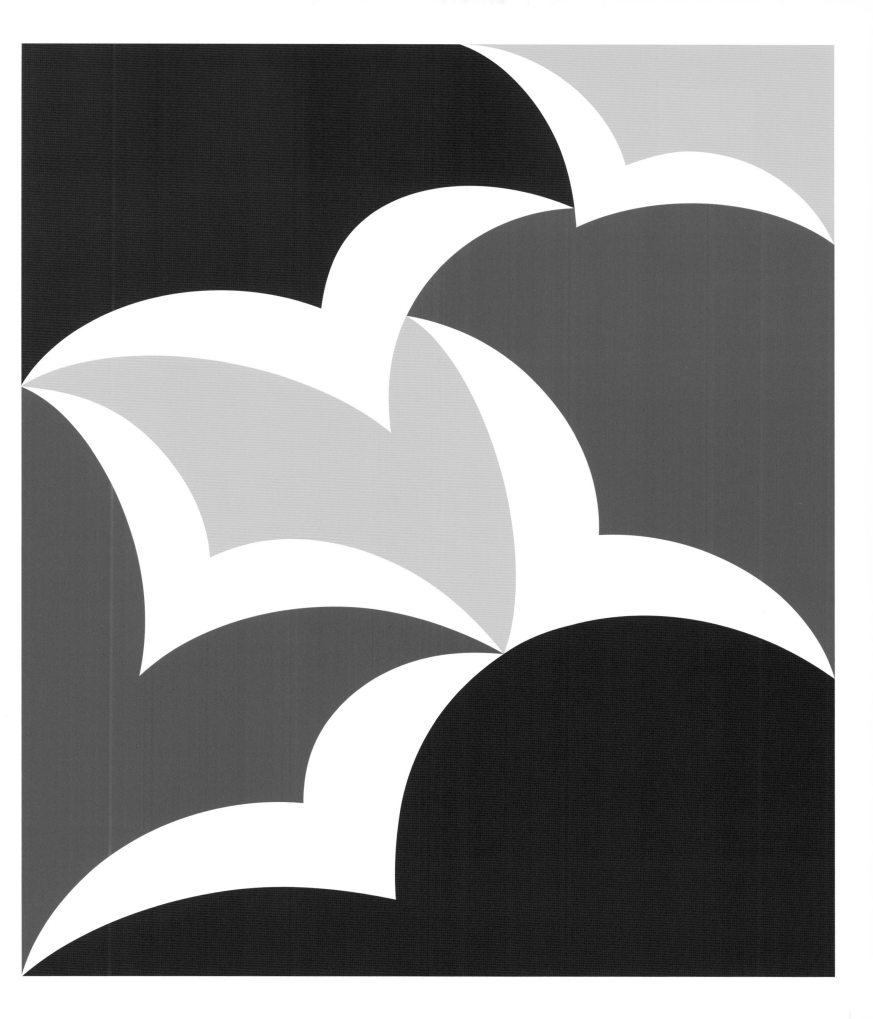

LYSTEKNISK SELSKAB

LOGO FOR DANISH ILLUMINATING ∧
ENGINEERING SOCIETY
1984

LES BONS VINS

POSTER >
100 x 70 CM
2002

" For centuries Languedoc has been a quantitative cornucopia as far as wine production has been concerned. But wine changes and the world changes and pokes its nose in, and Languedoc's mass producers were pushed up the mountain slopes to refine the product in the more inclement conditions that are oddly enough conducive to quality production (and I'm still talking about wine). Up there it's harsh – it freezes and blows and rains ... but at the end of the rainbow the reward sits well in the glass."

MUSCAT DE SAINT JEAN DE MINERVOIS MUSCAT DE LUNEL
COTEAUX DU LANGUEDOC MUSCAT DE MIREVAL CABARDÈS
MINERVOIS LA LIVINIÈRE FITOU SAINT-CHINIAN LIMOUX
CORBIÈRES MUSCAT DE FRONTIGNAN MINERVOIS
FAUGÈRES CLAIRETTE DU LANGUEDOC MALEPÈRE

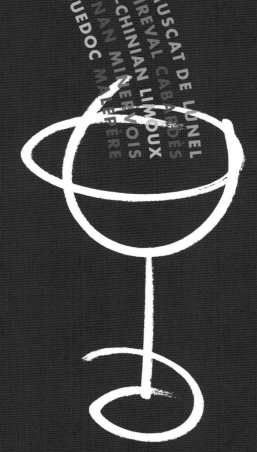

LES **BONS** VINS DU LANGUEDOC

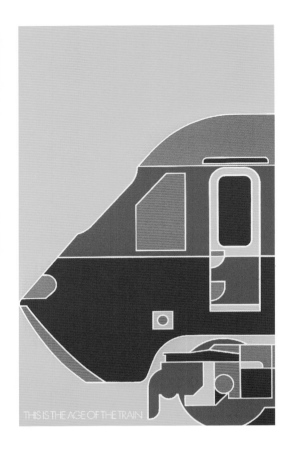
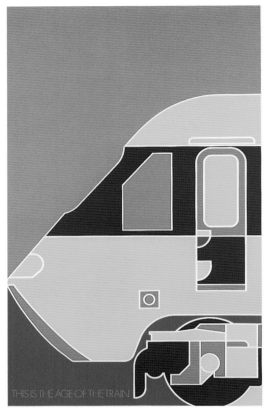

THIS IS THE AGE OF THE TRAIN

POSTERS FOR BRITISH RAILS ∧ >

100 x 64 CM

1982

> " The shape of the snout on British Rail's new high-speed train is so striking that there was no reason to search for any other applicable image.
> I divided the design up into a jigsaw puzzle in six colours: two blues, two reds and two yellows, and then switched them around in pairs so that three variants arose, which I then thought would fit together and shine brightly from far stations in Great Britain. The posters were only printed in very few copies and were abandoned without anyone really knowing why, and were instantly transformed into a hysterically coveted brand-new antique.
> This may be the age of the train but not the age of these posters."

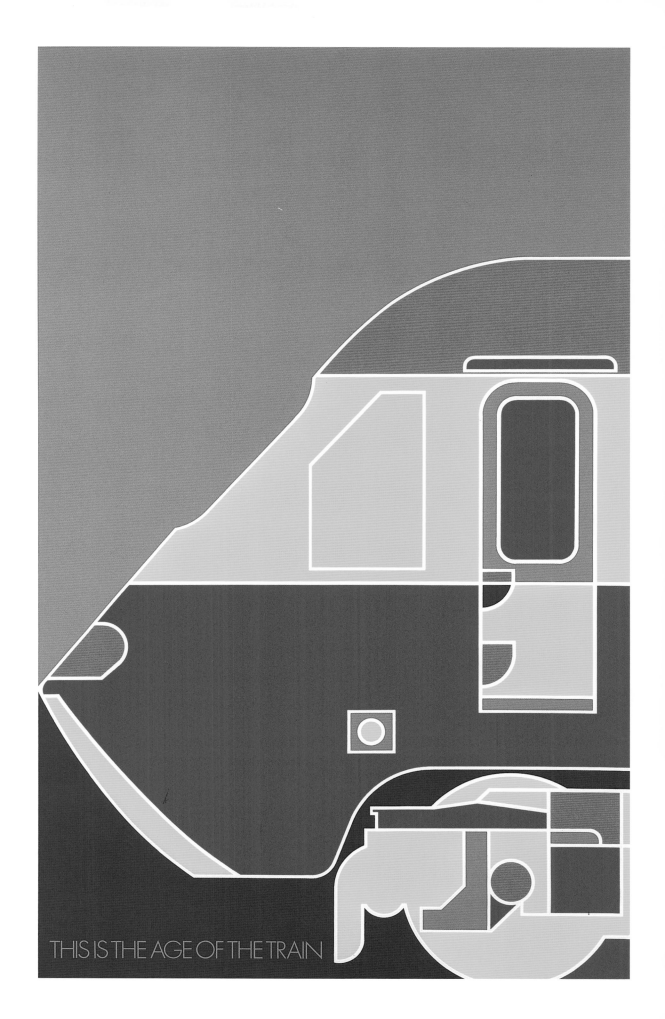

DANISH ATHLETICS FEDERATION CENTENARY

LOGO ∧
1996

BOXING

POSTER >
100 x 70 CM
1996

" Boxing is a violent sport, so the red splash I had used
so many times was an obvious possibility ... but the
blood-splattering tumult of the fight is still, they claim, subject
to certain rules and a certain order within an illuminated square
and surrounded by the ropes of the ring ... and that was what
I chose to emphasize.
And when the tumult breaks out, you might wonder whether
they are there to keep the boxers in or the spectators out?
But before it all starts, the ring marks out its little shining symbol
amidst the buzzing excitement of the hall."

EUROPEAN BOXING CHAMPIONSHIPS

IDRÆTTENS HUS - VEJLE · **DANMARK** · 30. MARTS - 7. APRIL **1996**

OLYMPISK KVALIFIKATION TIL **OL** I ATLANTA

BILLETSALG TLF. 75 83 72 22

ARRANGØR **EABA** OG **DABU**

INDELEDENDE KAMPE

30. MARTS KL. 18.30
31. MARTS KL. 14.00 OG 19.00
1. APRIL KL. 14.00 OG 19.00
2. APRIL KL. 14.00 OG 19.00

KVARTFINALER

3. APRIL KL. 14.00 OG 19.00
4. APRIL KL. 14.00 OG 19.00

SEMIFINALER

5. APRIL KL. 14.00
6. APRIL KL. 14.00

FINALER

7. APRIL KL. 14.00

DESIGN ARNOLDI © 1996

FAIR PLAY

LOGO FOR IMMIGRANT ORGANIZATION ∧

2001

OPEN HOUSE

POSTER >

100 x 70 CM

1987

" The boarding house in Svogerslev is a spacious, caring environment for mentally vulnerable residents. Once a year they hold an Open House. The message is so simple that there was no reason for artistic subtleties. A poster for an Open House: an open house ... and, one hopes, a party so good that it raises the roof!"

ÅBENT HUS

MINIFESTIVAL · PENSIONATET I SVOGERSLEV · MARIEVEJ 8—20 · LØRDAG DEN 1. AUGUST 1987 KL. 14—23

KUNSTHALLEN BRANDTS KLÆDEFABRIK

LOGO ∧
2000

COLORPRINT A/S

POSTER >
100 x 70 CM
1987

> **"** Colorprint is a printing firm spelled with a 'C', which can print lots of colours on both sides of the paper at once, as can be seen from the poster for the opening of the firm ..."

COLORPRINT A/S

SKETCH

2003 • ∧

SEANCE

POSTER FOR THE THEATRE BÅDTEATRET >
COPENHAGEN
80 x 60 CM
2001

❝ The stage lights contribute to all the illusions of the
performance ... not to clarify or illuminate or to bring
any kind of enlightenment about the game being played here.
Here too all hope is abandoned because the text about
the three people's claustrophobic and erotic games in a very
enclosed space shuts the light out and in.
The light we see is not at the end of any tunnel. It is the
moon's ice-cold nightmare and the interrogator's
inquisitorial spotlight glaring in the face of the theatre.❞

SEANCE

AF **JOKUM ROHDE**

MED **DAVID ROUSING, RIE NØRGAARD OG RASMUS BOTOFT**

ISCENESÆTTELSE **PETER DUPONT WEISS**

SCENOGRAFI **CHRISTIAN FRIEDLÄNDER**

20 SEPTEMBER - 31 OKTOBER

MANDAG TIL FREDAG 20.00, LØRDAG 17.00

BILLETTER 33 12 14 60

BILLETNET 7015 65 65

BÅDTEATRET NYHAVN 16

BÅDTEATRET

LEICESTER SQUARE LONDON

LOGO • ∧
1992

CANARY WHARF

POSTER FOR LONDON UNDERGROUND >
100 x 67 CM
2000

NORMAN FOSTER LOUISIANA

POSTER FOR EXHIBITION >>
140 x 100 CM
2001

VALENCIA

POSTER FOR PALACIO DE CONGRESOS >>
400 x 100 CM
1998

 ❝ Of course it's a wonderful situation when the subject a poster has to present, articulate and communicate, itself offers the obvious image.

And it's hardly surprising that that has been the case in the three cases where the subject of the poster has been the inauguration of or an exhibition about buildings designed by Norman Foster, with all the iconographic energy with which Foster always completes his buildings.

What I mean is that in that case it's already designed. But from the design to the sign that is the essence of the poster, there's still some way to go. The sign still has to be fine-tuned and reduced to the absolutely essential to be read clearly.

So it may well be that I removed some of the columns below the fantastic roof overhang in Valencia, switched on a glowing light in Swiss Re's tall office building in London or exaggerated the depth of the Tube under Canary Wharf Station on the Jubilee Line in London with another sweeping gesture:

The founding gesture of the poster!❞

CANARY WHARF

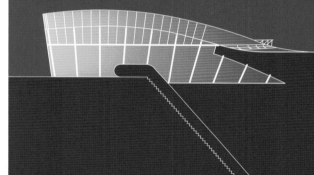

NORMAN Arkitekturens værksteder 8. 9. – 9.12. 2001
FOSTER

Swiss Re London

LOUISIANA

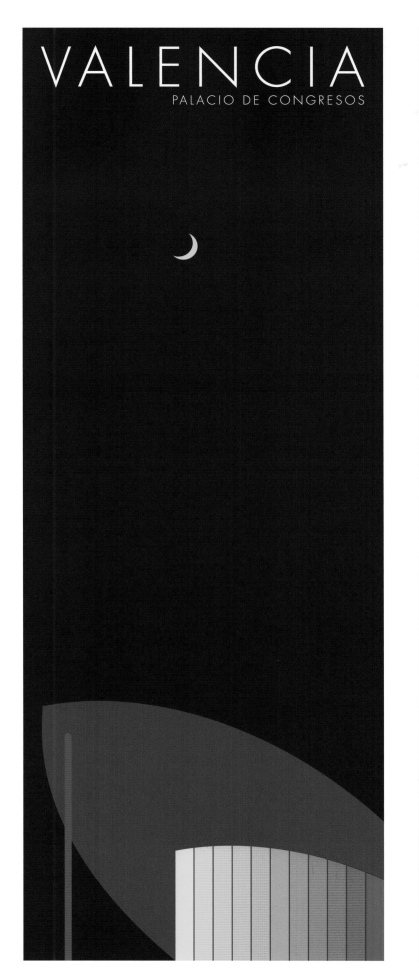
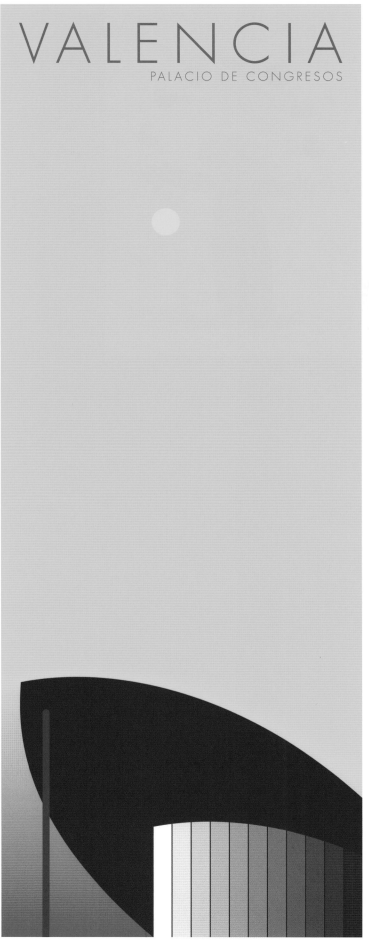

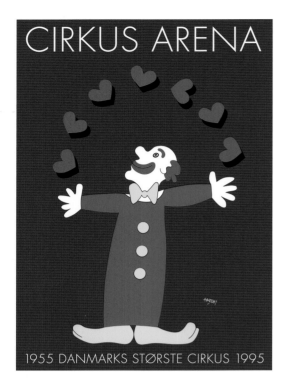

CIRKUS ARENA 40TH ANNIVERSARY

POSTER <

86 x 61 CM

1995

CIRKUS ARENA

POSTER >

100 x 70 CM

1974

" The small Circus Arena once put up its big top and hammered in its long pegs so efficiently near where I lived as a child that the lights went out all over the neighbourhood because they'd hit a cable. I've never forgotten what hit me when the brave little show started up in the middle of town, somewhere midway in its career between the minimum mountebank tent with two dogs and a dove and the daring dream of ending up as a three-ring elegant elephant circus – which came true. When I was fourteen I stuck my neck out and painted a facade for Arena that was just as painfully helpless as the performing dogs; but when we were all twenty years older and the 'top' was much bigger, I had the chance to do another one.
There's no getting round Lautrec if you do your homework and want to learn to make posters; and why would you want to get around him? He did a tent facade for La Goulue's little dance show.
I knew I was in good company..."

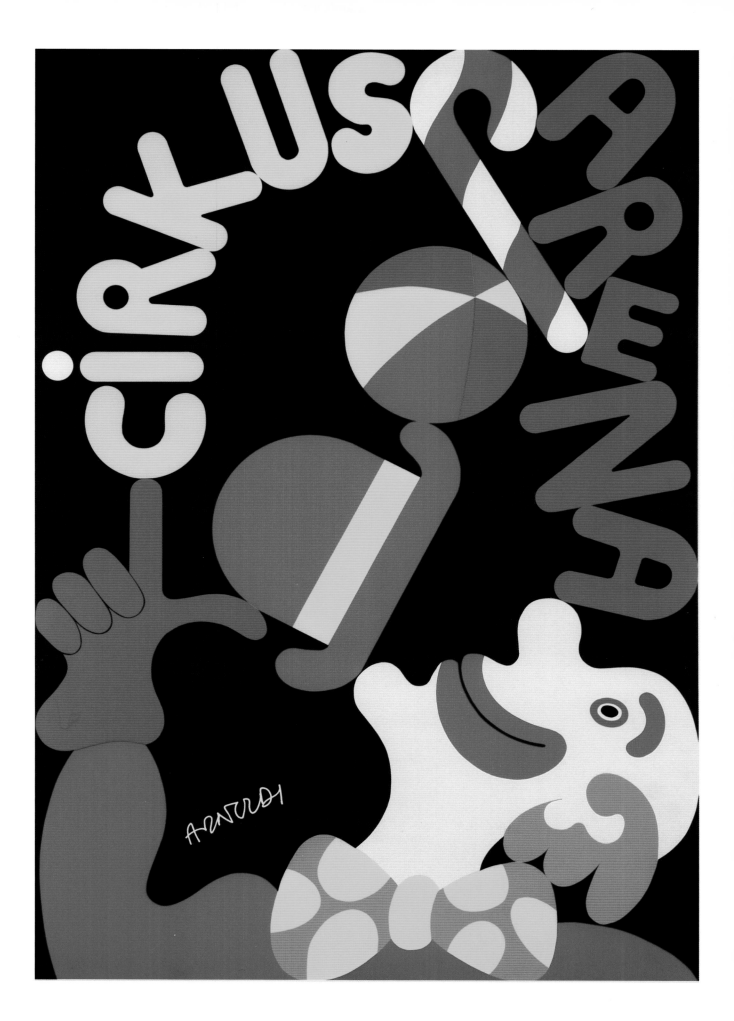

FIFI OSCARD AND ASSOC.
NEW YORK

LOGO • ∧
1984

MUSEUM OF CONTEMPORARY ART
CHICAGO 21 YEARS

POSTER >
120 x 80 CM
1991

❝ In Chicago 'order' is the order of
the day (in fact this was where
the Bauhaus reappeared after being closed
down by the Nazis), or at any rate there's
order in the street grid south of Lake
Michigan which includes the address of the
Chicago Museum of Contemporary Art.
Its magnificently odd-numbered 21st
birthday was celebrated with a big party at
the museum, emptied for the occasion to
make room for a one-off exhibition in the
simplest sense of the word.
Just one poster – this one – where the
museum glows on the grid like a 'getting-
warmer' sign in the middle of Chicago's
boogie-woogie grid. But the one poster was
repeated everywhere in 200 copies on the
museum walls.
One-man, one-poster, one-night show.
Monomania!❞

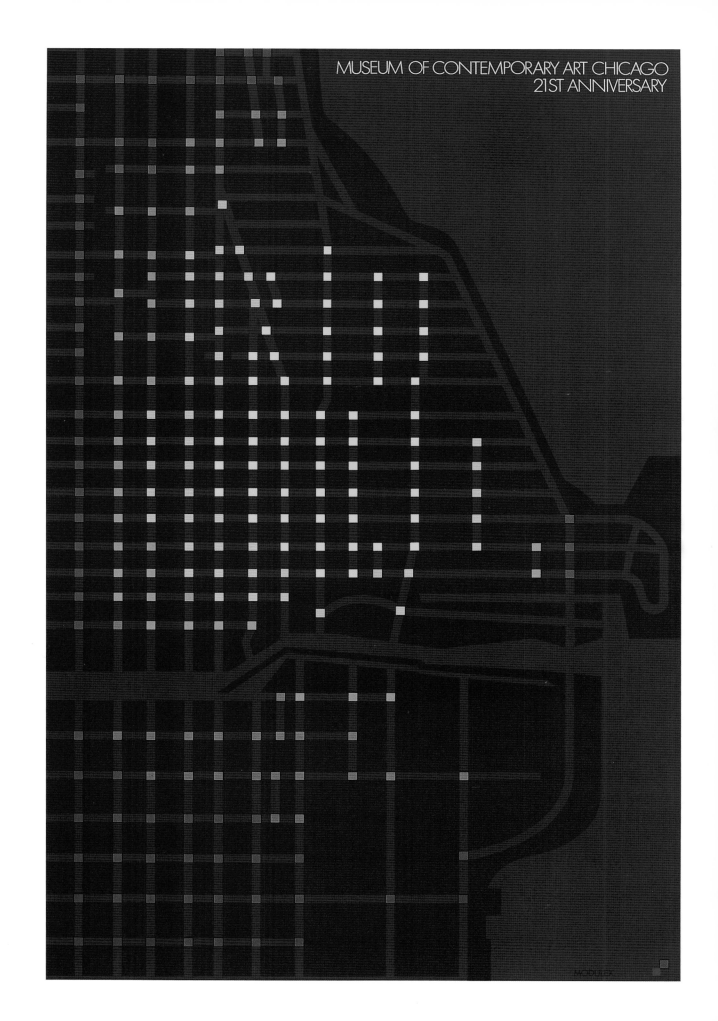

FISKERS KULTURBIBLIOTEK

LOGO FOR PUBLISHER FISKERS FORLAG ∧

1992

**CHICAGO SYMPHONY ORCHESTRA
100 YEARS**

POSTER >

100 x 70 CM

1990

" If only 'symphony' too had been spelled with a 'C',
my capital letter for the Chicago Symphony Centennial would
have covered the whole thing perfectly. Composed of a Bach
and a Mozart sheet of music the slightly sporty mega-C
still did the trick recognizably and well. When the orchestra's
conductor, Sir Georg Solti, was presented with my draft
for approval, he hummed both motifs of the motif and nodded
... the music had his blessing!"

1890 1990
CHICAGO SYMPHONY ORCHESTRA

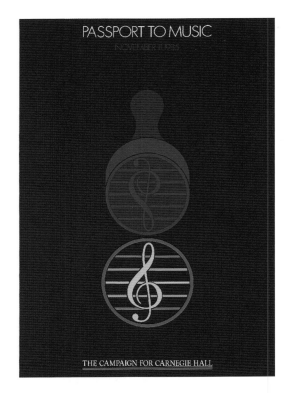

PASSPORT TO MUSIC NEW YORK

POSTERS
THE CAMPAIGN FOR CARNEGIE HALL
 50 x 35 CM <
100 x 70 CM >
1985

LYRIC OPERA OF CHICAGO

POSTERS >>
91 x 64 CM
1994 / 2001

“ The Campaign for Carnegie Hall was a big project;
a whole series of initiatives meant to raise 50 million dollars
for the restoration of the 94-year-old concert hall building
in New York.

On 11th November an event was held under the title
Passport to Music. Twelve envelopes were auctioned off, one
for each month of the year.

Each envelope contained two tickets for a musical event
somewhere in the world, from Glyndebourne to Israel, from
Nashville to Vienna.

With festivity and colour and 'meet the artists' and of course
with the plane tickets which on the poster folded into a
darting Bach score and launched it optimistically in the right
direction ...”

THE CAMPAIGN FOR CARNEGIE HALL

LYRIC OPERA OF CHICAGO

THE CIVIC OPERA HOVSE

40TH ANNIVERSARY SEASON 1994-95

LYRIC OPERA OF CHICAGO
2000 2001

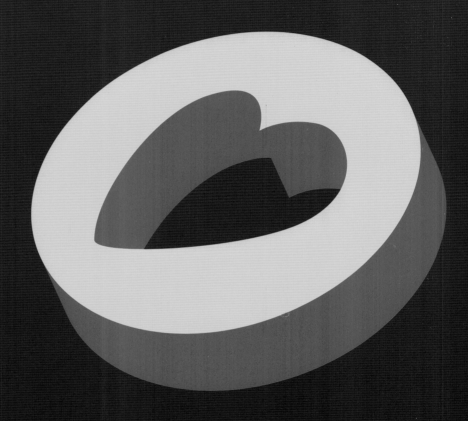

POSTER MADE POSSIBLE BY A GENEROUS GIFT FROM WINSTON & STRAWN

ODIN GROUP NEW YORK

LOGO ∧
1988

CLINTON

POSTER >
70 x 50 CM
1997

> "President Bill Clinton was to pay a visit to Copenhagen in March 1997 and talk to the people at a suitable place in the city. Not too small and not too big. The subject would be peace, announced the White House, which had commissioned a poster for the occasion through the Danish Foreign Ministry.
> Peace! So I made the microphone cable outline a dove which, as the pigeons on the selected city square do, had perched on the microphone. A dove for peace and for Copenhagen. And that was about all there was to that bird on a wire.
> But Clinton broke his leg in Florida and cancelled, and we stored away a huge impression of this poster with the wrong date, saved like a philatelist's misprint, and then printed a new version when he fortunately did come in July.
> The poster never went up in the city ...
> I think the event turned it into an instant collector's item ... the whole impression disappeared into thin air and is now appearing for sale.
> One man's roundabout is another man's swing."

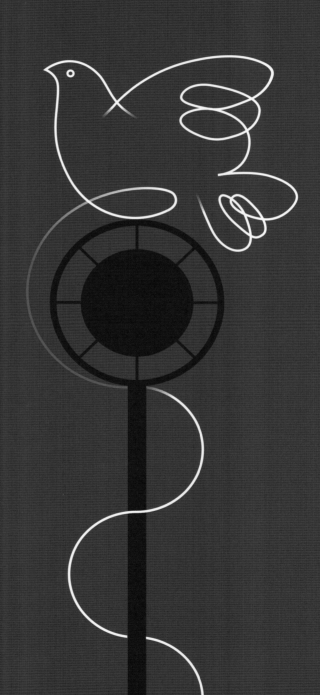

PRÆSIDENT

CLINTON

TALER

NYTORV · KØBENHAVN · **12/7** · 1997 · KL. **15.30** · ADG. FRA KL.14.00

BELLA CUCINA / ODIN GROUP USA

LOGO /\
1988

COMMUNICATION

POSTER FOR >
CERTIFIED ELECTRICIANS
80 x 60 CM
1990

" Bella Cucina was a mail order kitchenware firm started
in New York a long time ago by the Odin Group, for whom
I had earlier designed a logo:
A two-piece O – O for Odin, and twofold and two-coloured for
diversity.
A new logo was ordered.
Piece of cake, I thought, and only had to turn the two-colour O
on edge, so now they had fire and pot and lid and dish and
whatever else they dreamed of selling. How lucky can you get?"

KOMMUNIKATION KOMMUNIKATION KOMMUNIKATION KOMMUNIKATION KOMMUNIKATION

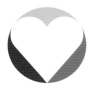

LOGO

2003 • ∧

OSCAR PETERSON

POSTER FOR JAZZ CLUB MONTMARTRE >
120 x 82 CM
1976

" In the twenties the piano lids jiggled in time with the cocktail glasses when the motif had to be jazzed up in the style of the period.

A couple of the expressions that have been used in the history of style to label and explain some of these stylistic features were in fact Jazz-Modern and Zig Zag Modern.

I thought the old motif, the piano top, could be used again, but should end up straight for Oscar Peterson's concert at Jazz Club Montmartre."

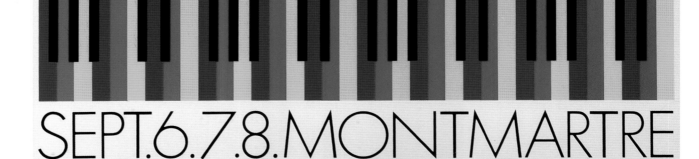

GLOBAL CITY

LOGO FOR ∧
WORLD ECONOMIC FORUM GENEVA
1995

COPENHAGEN AIRPORT KASTRUP

POSTER >
100 x 70 CM
1982

" An air*port* has to be a haven, the opposite of the airwaves of the high seas. Haven is here and home, and very homely, very down-to-earth in Kastrup in Denmark.
The little plane has put down its steps amidst the idyll and has no intention of flying off anywhere ..."

KASTRUP

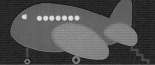

COPENHAGEN AIRPORT

JØRGEN LETH PRODUCTION

LOGO ∧
1991

DANISH FILMS

POSTER >
CANNES FILM FESTIVAL
120 x 70 CM
1978

" In 1978, for the optimistic stand that was trying to sell Danish state-funded films at the festival in Cannes in May, I designed a series of posters, of which this one is the 'parent poster'. Film festival posters, which in the nature of things appear all together at the same time in the same place for a short while with the same range of motifs, have to struggle with an endless series of variations on the same set of clichés: clapperboard, strip of film, perforations, clapperboard, clapperboard and projectors and projections and director's chair and clapperboard.

I thought about the fact that the 10,000 people who course through Cannes in the course of the festival, in and out and round about the cinemas and one another, also talk. They put words to the pictures. Producers, actors, directors, cameramen, light men and sound ladies and vice versa, glittering stars and fading fans – all of them also use words about the films they've seen, will see, won't see or pretend they've seen. As much goes on with the films in the daylight as in the dark. So – a poster with a little list of the things that one could reasonable say – at least we thought so – that Danish films had to offer and surprise you with that particular year. Each of the words then made up a single poster, and half a million matchbooks and catalogues and postcards and so on. In all discretion"

ART
FUN
LOVE
THRILL
BEAUTY

DANISH FILMS

THE DANISH STAND 4TH FLOOR PALAIS DES FESTIVALS

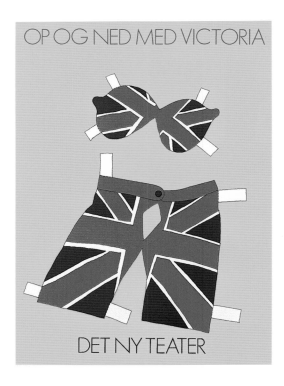

OP OG NED MED VICTORIA

DET NY TEATER

UP AND DOWN WITH VICTORIA

POSTER FOR THEATRE DET NY TEATER <
COPENHAGEN
85 x 62 CM
1982

FEDERATION OF DANISH ARTISTES
50 YEARS

POSTER >
100 x 70 CM
1978

" The Federation of Danish Artistes is a wonderful trade union that binds together a rampant, luxuriant jungle of individualists with a deep-rooted solidarity.

Sword-swallowers and ventriloquists, contortionists and snake-charmers, trapeze girls and Shakespearean actors, high-wire walkers and harlequins, party-game pundits, people you pay to pick your pockets, and huge travelling families that sprout cotton-wool whiskers in the festive season. The unifying symbol for an anniversary poster didn't seem obvious with such a grotesquely disparate group of professions.

What they do share, though, is the conviction that life is only lived and felt when a performance twinkles like a star. On the conjuror's little draped table the tricks come shooting up from the elegant up-ended big top hat that belongs to both the biggest stage and the smallest circus. To mark the anniversary the poster went on sale to set up a benefit fund for the artistes.

I've seen several copies after they had been sold to the members. The owners, the artistes, had 'completed' the slightly old-fashioned stars in the very spirit in which they were made by filling in the white spaces with their own wonderfully international-sounding artiste names. The chaotic graphic clash of handwriting and print transformed my slightly purist poster into an object that finally looked as I should perhaps have made it from the start, if I'd thought of adding another layer. Now it has exactly the lovely look of the circus poster that prints the town names along its route, the text jiggling along below, or the variety poster that has to change the programme if anyone has fallen down or not turned up."

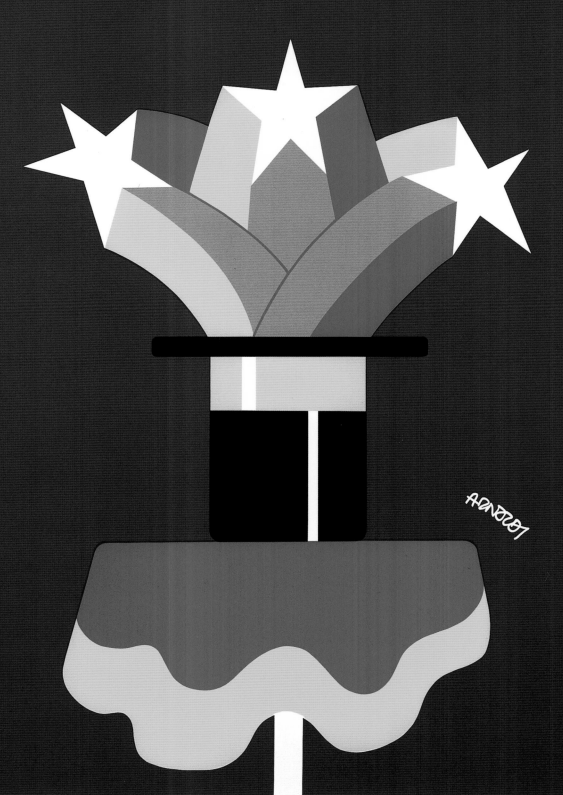

HEBSGAARD GLASS & FRAMES

LOGO /\
1992

DANSK MØBELKONTROL 25 YEARS

POSTER >
100 x 70 CM
1984

" Dansk Møbelkontrol is the furniture quality control organization that has subjected the furniture that rises to the top, in terms of design, exports and artistic value, to a whole barrage of tough tests – weighing down and tilting, cold and heat and peak load, water and wind, weighing them in the balance and deeming them good enough for the top step of the poster out in the real world."

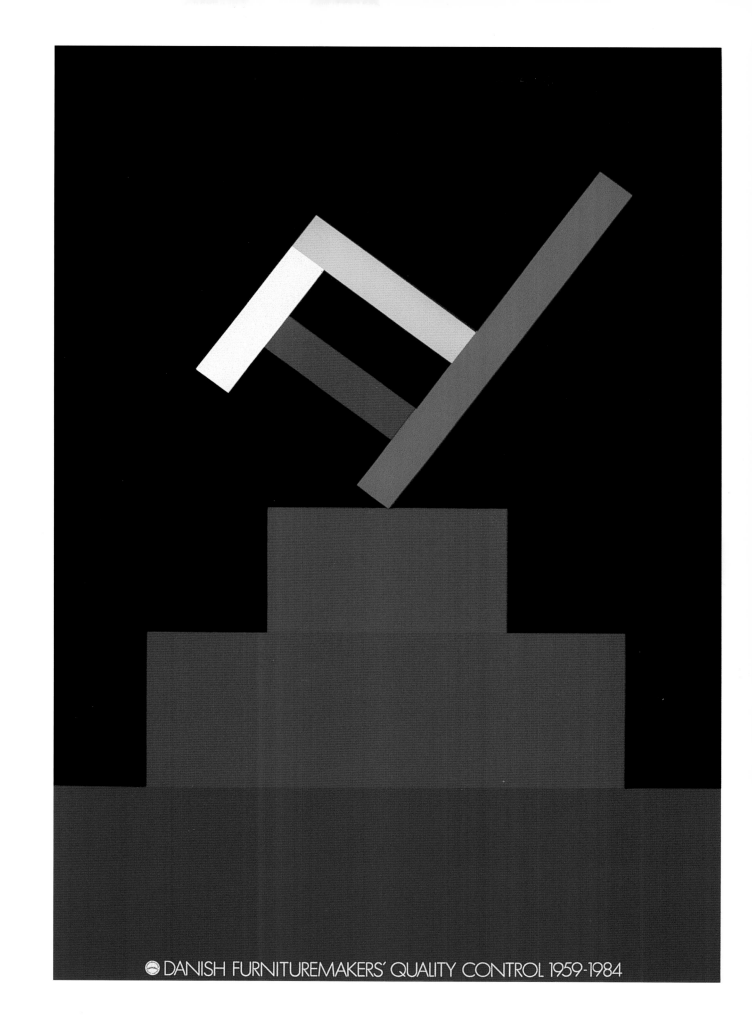

DANISH FURNITUREMAKERS' QUALITY CONTROL 1959-1984

OPERA de LYON

" Jean Nouvel's new opera building within an opera building within the city of Lyons vaults in a high majestic circle out of the old shell ... an enormous 'O' for Opera, burstingly potent and, I thought – in a new logo and information strategy for the Opera – almost like a flying saucer, a building that has taken off. A spinning 'O' heading at full tilt into the future."

Place de la Comédie
69001 Lyon
04 72 00 45 45
www.opera-lyon.com

OPERA de LYON

LES NEGRES

" Mais, qu'est-
ce donc
qu'un Noir ?
Et d'abord, c'est de
quelle couleur ?
Jean Genet

MICHAEL LEVINAS

CRÉATION MONDIALE
LIVRET DU COMPOSITEUR
D'APRÈS LA PIÈCE DE **JEAN GENET**
BERNHARD KONTARSKY DIRECTION MUSICALE
STANISLAS NORDEY MISE EN SCÈNE
ORCHESTRE ET CHŒURS
DE L'OPERA DE LYON

TARIFS : DE 5 À 80 €

JANVIER 2004
MA 20 20H | JE 22 20H | SA 24 20H
LU 26 20H | ME 28 20H | VE 30 20H

PLACES A 8€
POUR LES
-28 ANS

**SCHWAB FOUNDATION
FOR SOCIAL ENTREPRENEURSHIP GENEVA**

LOGO ∧
2000

DEUTSCHE BANK

POSTER • >
100 x 70 CM
1995

" Microeconomics – or rather, an
example of microeconomics – is
when a hundred very poor Indian women
each borrow ten dollars for a sewing
machine and it works and it works again
and a network of very modest but crucial
initiatives flourishes, and a constantly
growing succession of mini-borrowers are
enabled to help their families and take the
first, hardest step out of hopeless poverty.
The Schwab Foundation originated in
the diametrically opposite network in the
very macroeconomic world:
the World Economic Forum in Geneva.
The foundation identifies, makes visible
and supports such initiatives all over the
world ... It's all right if it spreads ... but it
doesn't do so all by itself.
My logo points and pieces the scattered
elements together in a shining symbol."

DYNAMIK

KOMPETENZ

INNOVATION

VERANTWORTUNG

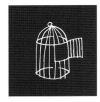

ISAAC

LOGO ∧
2000

DUPONT

POSTER >
60 x 42 CM
1980

" ISAAC is an international organization, the International Society for Augmentative and Alternative Communication, which battles to remedy severe disabilities, or perhaps more precisely invents, develops, tests and implements a never-ending succession of ingenious resources that enable the multi-handicapped to function better and especially to communicate better.

My cage for the 2000 congress in Odense is open ... the bird may have trouble flying ... but it has been set free!"

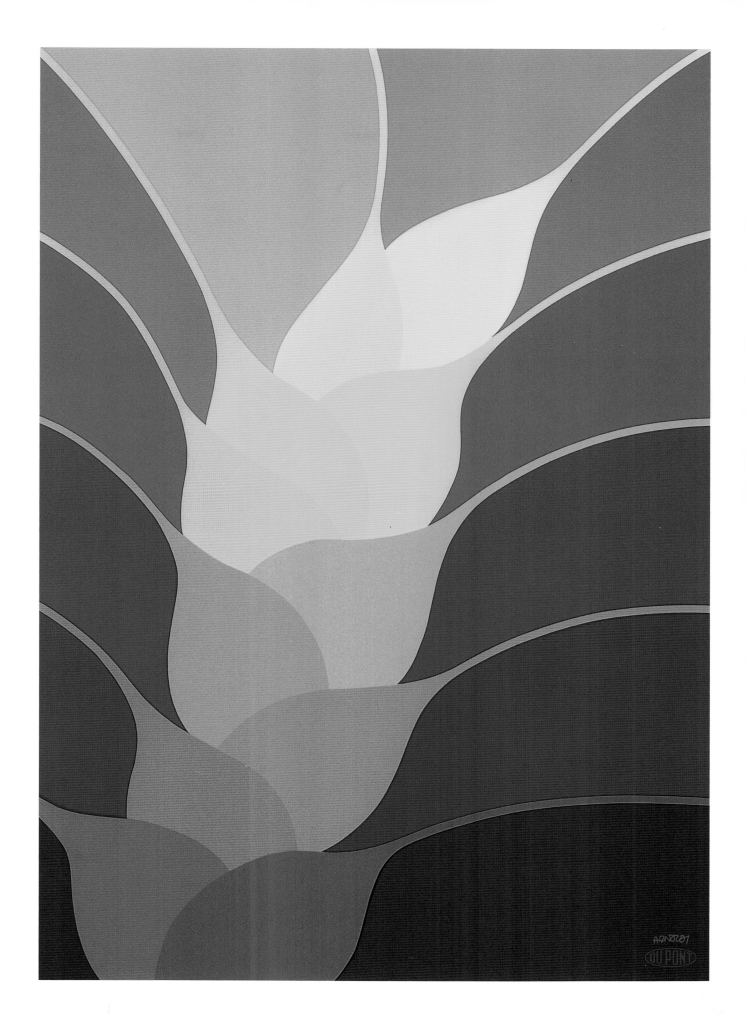

FAF

LOGO FOR \wedge
ASSOCIATION OF FILM AND TV WORKERS
1998

THE CAMERATA CHOIR

POSTER $>$
100 x 70 CM
1996

66 Camerata is a choir, and the bird is a symbol of
song, I think, so there's nothing to make a song about there.
The species is my own invention: a songbird ..."

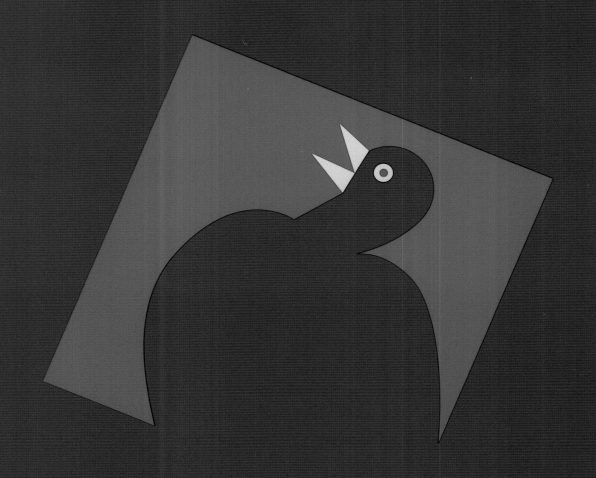

Kammerkoret

CAMERATA

HEMPEL SKIBSFARVER

LOGO FOR SHIP PAINT ∧
1992

DET FRANSKE VINLAGER

POSTER >
120 x 80 CM
1975

" The cocktail glass and the champagne bottle, and the top hats on the gentlemen, and the long cigarette-holders in the ladies' hands, and the guests zig-zagging like mad in the style of the time to the jazz of the time in the great graphic age of the thirties are sandblasted and mirrored in the back wall of the bar. So you get dizzy before you're done.
But so as not to get too giddy with a wine poster for the French wine importer I chose to stick to the fact that the wine stays level-headed, and so as not to lose the allusion to the zigging and the zagging I tilted the surroundings with the same ultimate effect ..."

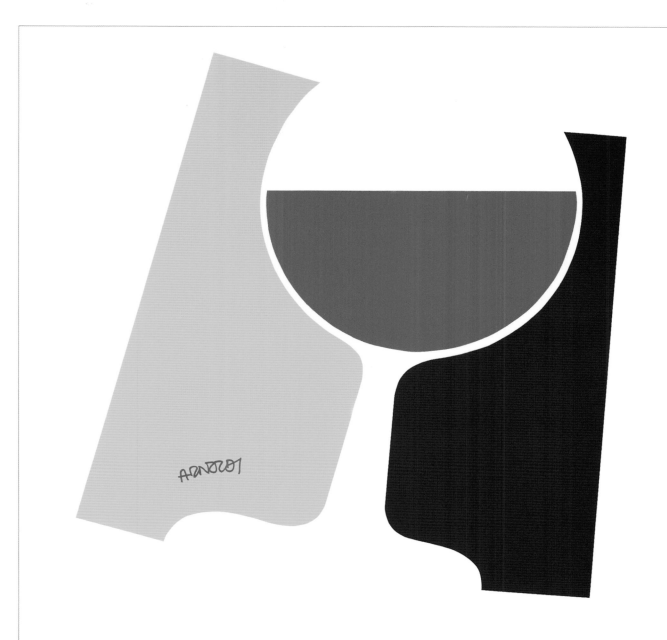

CHATEAU
ANDRON BLANQUET 1975
importé par
DET FRANSKE VINLAGER A/S

SID

LOGO FOR THE WORKERS' UNION • ∧
1998

COMMUNICATION

POSTER FOR DEUTSCHES POSTER MUSEUM >
SCHLIEPER & CO
ESSEN
100 x 70 CM
1994

" I have stubbornly insisted that the best
communication is the message that moves, with no
digressions, as directly as possible from sender
to receiver. But in this case, where I had to give an
account of my theory in a poster about communication
on a strict-schoolmasterish blackboard background,
a butterfly flew off with the chalk and traced out
the kind of communication where poetic detours can
also bring the message straight home!
What is one to believe?"

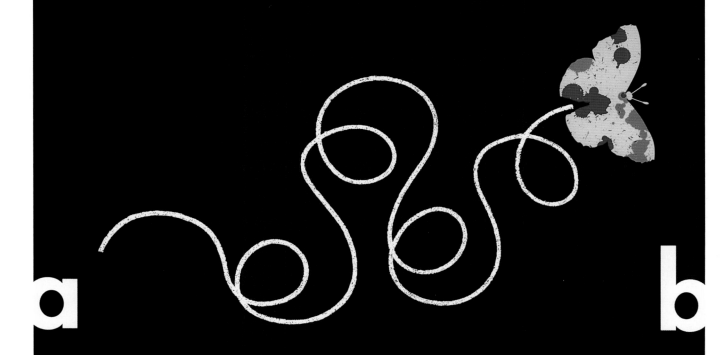

HUBERT STRAUF EDITION . PER ARNOLDI : KOMMUNIKATION . JUNI 1994 . DEUTSCHES PLAKAT MUSEUM . SCHLIEPER+CO ESSEN

ARNOLDI · PLAKATER

DJURSLANDS MUSEUM · DANSK FISKERIMUSEUM · SØNDERGADE 1 · GRENAA · 14. JUNI · 30. AUGUST 1996

SKETCH

" The little country.
The railway posters from the great age of Cassandre and Pierre Masseau were emphatic: *Exactitude, vitesse, luxe et confort*. The future was within reach. The energetic engines of the modern age tore along in clouds of smoke and steam in the right direction and were always on time. The distances had to be covered and conquered quickly, and the conquest of the world at the end of the tracks was not only the vision of the passengers.
The smoking chimneys were still a positive image of potent industrialization.
The posters pointed forward ...
I didn't have the same possibility in 1975. Not because Danish Rail doesn't stay on the tracks, try to run on time and hit the planned destination, but because our knowledge and our attitudes and our time are different. And a poster has no other option and justification than to connect closely with the world that it is designed for in the here and now.
I chose the opposite image: the little country, the little toy train, the short distances, the high sky, the fickle weather, the many seasons, the trusting hope that the toy train would get safely through the idyll; a cautious dream that it will all turn out right, instead of the thundering self-assurance of the engines. We'll make it. The country isn't so big that, even in the worst snowfall, we can't get off and give the train a shove – or just go home again. In our contract on cooperation and copyright, when we came to a clause about what was to happen if the railway in another country wanted to buy the motif to advertise its own rail transport, we boldly signed. But the truth was blatantly obvious: what other country than toytown Denmark would want to represent a state institution so laughably, or perhaps so laughingly, as we have tried here ..."

DSB

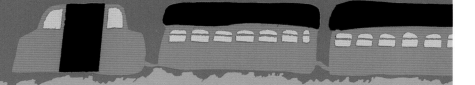

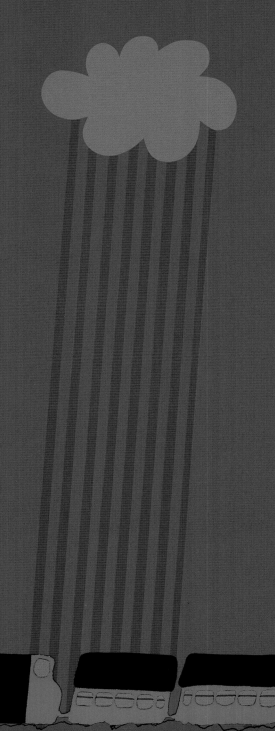

DSB

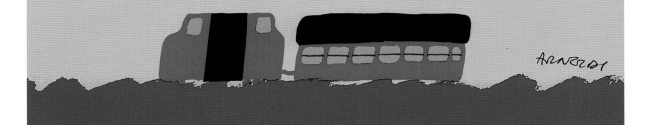

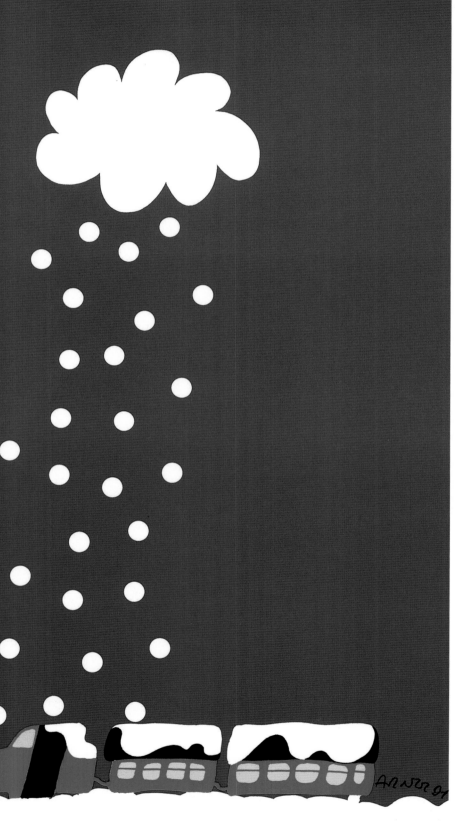

DSB

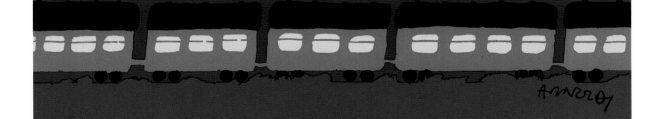

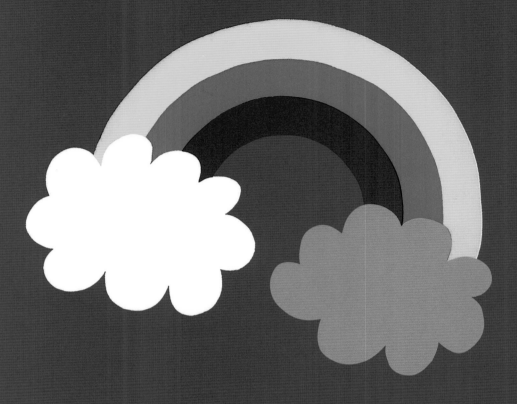

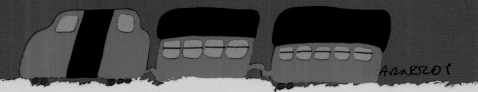

SKETCH

" It was still 'the little country' that came to mind 25 years later when I was asked to design a new series of posters for DSB (Danish Rail). Much had changed in Danish Rail and I suppose in the country too, and in my method of working. New times and new timetables called for a different idiom.

But the country still nestles as small and comfortable as it does, and I looked for a way in which, without overdoing the idyllic once more, I could show the very human and wonderfully manageable aspect of a limited area.

I tried a map of Denmark based on the rail network, where the distances between stations were given in kilometres, so and so many and especially so few from here to there.

But it turned out that the station names were much better bearers of the narrative than the stretches between them, so I realized I had arrived at my destination. The 295 stations are a map of Denmark that gets it all in – that is, if it is all in – and then there are two halts that only work in the summer, and which I left out.

Denmark is no bigger, and that's just fine. Here we have the stations we know all too well and those we don't even know we've been through, and those where we've never been and maybe now, looking at the name, might feel a twinge of longing to see.

A railway poster should include the ends and means as well as a touch of longing. And the trains are still running poetically along the lines of the epic Danish list-poem."

HJERM
RINGSTED · VEJLE SYGEHUS
ODDESUND NORD · KORSØR
ESPERGÆRDE · STUDSGÅRD
DYBBØLSBRO · VEDBÆK
HOLME-OLSTRUP · LYSTRUP
LANGERØD · GÅRDE · VEMB
KØBENHAVN H · SNEDSTED
HELLERUP · BJERRINGBRO
BEDSTED THY · STENLØSE
MØRKØV · THISTED · VOJENS
SVENDBORG · GIVE · VIRUM
FRUENS BØGE · MØRKE
HJORTSHØJ · SNEKKERSTEN
ISLEV
SKÆRBÆK · HØJE TAASTRUP
VEJEN · SKOVBRYNET · TOLNE
ROSKILDE · ORDRUP JELLING
ESKILSTRUP · RYPARKEN
KVISSEL · VARDE · HVIDOVRE
THYREGOD · ARDEN · IKAST
BRØNDERSLEV · STRUER · DSB

KAUSLUNDE · HØJBY FYN
NIVÅ · SVENDBORG VEST
TØLLØSE · SOLRØD STRAND
GELSTED · RINGE · UGLEV
TAULOV · FREDERIKSSUND
VISBY
BRØNDBY STRAND · EJBY
EUROPAPLADS · HOLSTEBRO
SKALBJERG · HERFØLGE · LYNGS
SEJSTRUP
RANDERS · BIRKERØD · VALBY
ODENSE SYGEHUS · REGSTRUP
KARLSLUNDE · LANGGADE
ULFBORG · KØGE · HADSTEN
TØNDER NORD · AALBORG
BREJNING · KOKKEDAL · TARM
SVANEMØLLEN · GØRDING
TAASTRUP · HOVMARKEN
VARDE NORD · KILDEBAKKE
BALLERUP · BORDING · MÅLØV
ENGESVANG · TORSØVEJ
AULUM · SKOLEBAKKEN · DSB

GULDAGER · RUNGSTED KYST
HVIDBJERG · BØRKOP · YDBY
BREDEBRO · RYOMGÅRD
SINDAL
ALLERØD · RIBE NØRREMARK
FUGLEBAKKEN · GADSTRUP
GENTOFTE · ØSTBANETORVET
KIBÆK · BRØNS · STOHOLM
VANLØSE · HJØRRING · ISHØJ
MALMPARKEN · VINDERUP
HOBRO · SJÆLØR · HASLEV
KLAMPENBORG · KOLIND
PADBORG · VAMDRUP · JERSIE
BUDDINGE · HARESKOV
VANGEDE · FREDENSBORG
BRØNDBYØSTER · VÆRLØSE
HOLTE · KLIPLEV · SKØDSTRUP
BRAMMING · JYLLINGEVEJ
LEJRE · KVISTGÅRD · HUSUM
HOLSTED · NÆSTVED NORD
SKODSBORG · TREKRONER

DSB

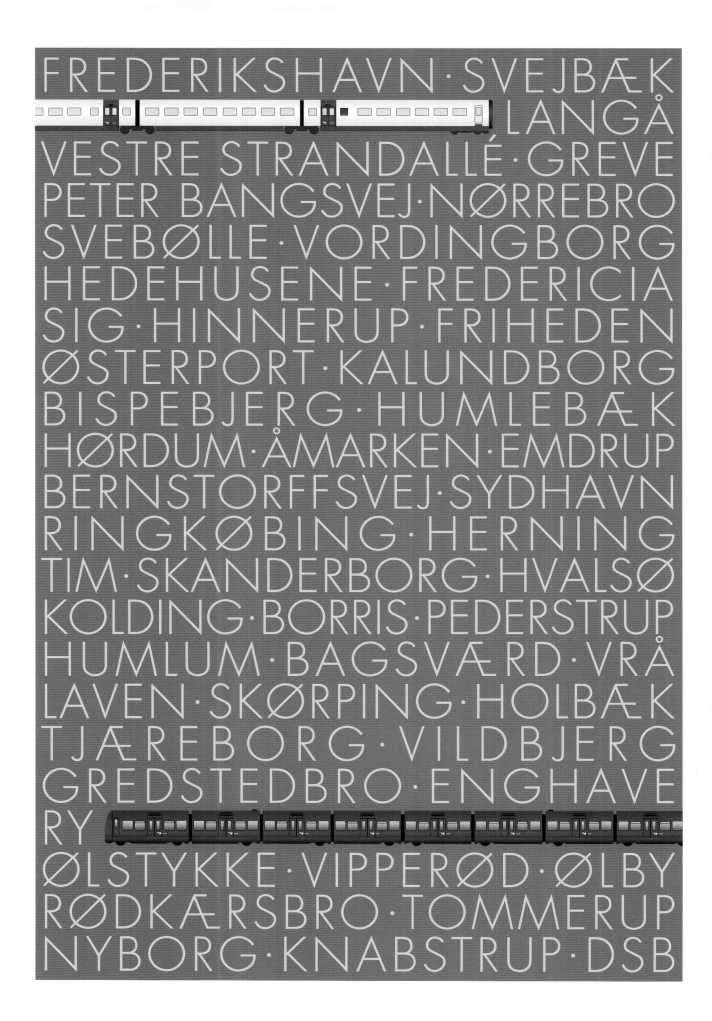

SILKEBORG · KVÆRNDRUP
MIDDELFART · NORDHAVN
GEDSER · SLAGELSE · VIBORG
NYKØBING F · HOLMSTRUP
SKOVLUNDE · LUNDERSKOV
ALKEN
BORUP · ÅRHUS H · ØRESTAD
HELSINGØR · GRØNHOLT
ULSTRUP · REJSBY · AVEDØRE
VIBY SJÆLLAND · RØDEKRO
TRUSTRUP · DYSSEGÅRD
BIRK CENTERPARK · ÅRSLEV
MØRDRUP · SKJERN · GLUMSØ
VESTERPORT · HUNDIGE
ODENSE · BRØRUP · HØJSLEV
LILLE SKENSVED · ARNBJERG
ØLGOD
TINGLEV · HJALLESE · FARUM
NØRRE ALSLEV · RØDOVRE
STENSTRUP · VALLENSBÆK
BRANDE · TUREBY · GRENAA
HORNSLET · TØNDER · DSB

CHARLOTTENLUND · VEKSØ
STENSTRUP SYD · GRØNDAL
TROLDHEDE · NØRREPORT
LUNDBY · VEJLE · LØGTEN
HEE · DEN PERMANENTE
ESBJERG · SØNDERBORG
BUR · TISTRUP · AARUP · SKIVE
KØBENHAVNS LUFTHAVN
RUDME · SJØRRING · HERLEV
HVIDING · VARDE KASERNE
GLOSTRUP · JÆGERSBORG
DØSTRUP SØNDERJYLLAND
ESBJERG NORD · JYDERUP
NØRRE-ÅBY · SORGENFRI
BRED · GRÅSTEN · NÆSTVED
RIBE
HORSENS · SORØ · LYNGBY
STENGÅRDEN · HILLERØD
HAVDRUP · RØDBY FÆRGE
LEM · TÅRNBY · HAMMERUM
ALBERTSLUND · HURUP THY
ELLEBJERG · KILDEDAL · DSB

PLUS **S**

PLUS S SAPPORO JAPAN

LOGO ∧
1990

JR HOKKAIDO JAPAN

POSTERS >
100 x 70 CM
1990

"In connection with the planning of
the railway services across the
planned Great Belt Bridge and through
the tunnel, Danish Rail consulted Japanese
Railways, who had many years of experience
from the world's longest underwater
tunnel, the Seikan Tunnel, which links the
main island Honshu with the northern
island of Hokkaido.
This consultation led to the establishment
of a 'sister railway collaboration' between
Danish Rail and the recently privatized
JR Hokkaido.
Since all proper railway operations need
posters, JR Hokkaido ordered a series
where I reduced and stylized the many
different weathers of my first Danish Rail
posters to fewer, and hopefully even
clearer motifs:
Three ... Japanese sun, rain and snow!"

JR·HOKKAIDO + DSB·DENMARK

JR·HOKKAIDO + DSB·DENMARK

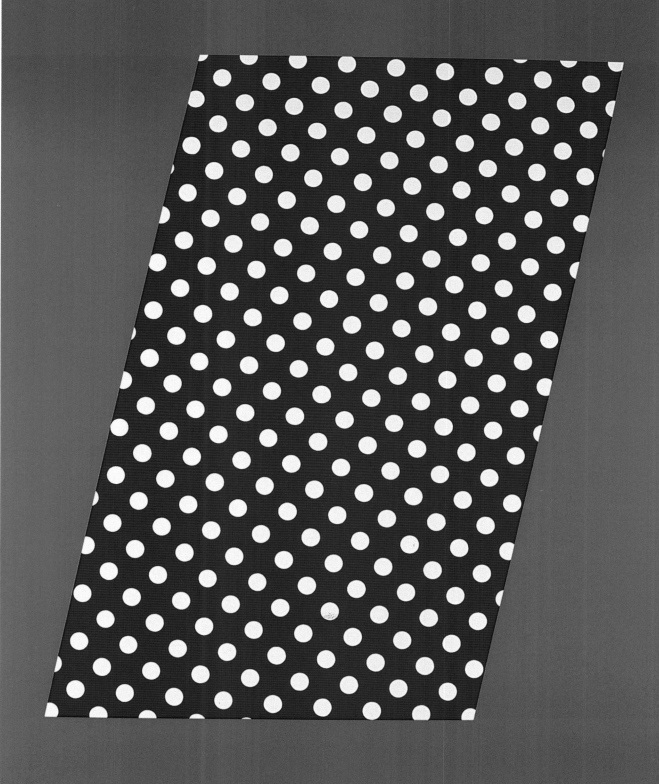

JR·HOKKAIDO + DSB·DENMARK

HANS CHRISTIAN ANDERSEN abc FOUNDATION

LOGO

2004 ∧

GALLE & JESSEN

COPENHAGEN >
1989

" A Gajol is a small liquorice pastille – here big
and black on the gable of the factory in Copenhagen ...
The factory has now moved, and the Gajol Man, as
he was called here in my childhood neighbourhood,
has been built over.
But the pastille is a classic!"

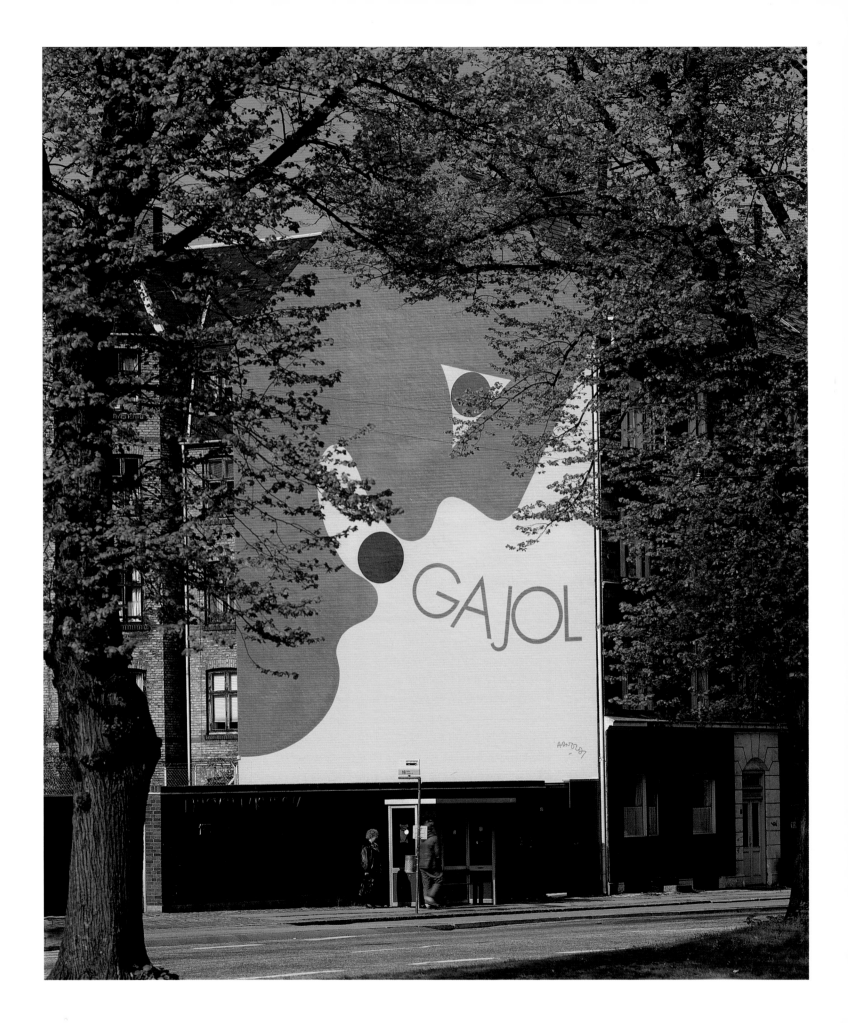

HBI

HENRI BEAUFOUR WASHINGTON DC

LOGO FOR <
HENRI BEAUFOUR INSTITUTE •
1991

DIZZY GILLESPIE

POSTER FOR >
THE JAZZ EXCHANGE ASSOCIATION
100 x 70 CM
1978

"The poster for Dizzy Gillespie was commissioned as promotion for the association Jazz Exchange, but actually came to mark the end of the association. Posters can be perilous!

Jazz Exchange was a small, brave, idealistic association that organized bold, progressive well-informed tours for European and American jazz musicians at points in their careers when both Europe and the USA were too far away for them to be booked as soloists.

To increase the membership, Jazz Club Montmartre in Copenhagen and Jazz Exchange joined forces in an optimistic project where Dizzy Gillespie was to play anyway, and the evening's income from bar or gate was to go to the association.

I was to design a poster which besides saying where and when and why, was to be a carrot tempting members of the audience that night to join the association.

Dizzy Gillespie was to be appointed an honorary member, and would thus increase the total membership to fifty. Finally, we were jointly to sign a limited edition of the poster to raise money for the printing and the continued activities of the association.

Dizzy had already designed the poster for me by bending his horn. Now and then you can go for the soft option without too many smart moves – it's enough to draw what you're talking about as directly as possible.

Arrange the text, clean and spread the paint, supervise production and otherwise keep your hands to yourself until you have to clap at the result.

The structure of the text was very simple. Four lines, four type sizes, the same type. Dizzy in full width. Gillespie and Montmartre in the same width in the next size. 'Supports Jazz Exchange' over half of the next line, and thus a third size. And finally, again as half of the preceding line, the information on where and when, in the smallest type size.

The only thing missing from the poster is this fourth line, and the information, and the only thing missing that day was Dizzy Gillespie, who was unfortunately ill and in Holland.

We managed to remove the text in time. We kept the poster with the little logical flaw in the typography, and hoped we could later print a new date in the same place, in the same size, if we could again get the package together. The association didn't live much longer.

Since then the poster has lived a life of its own and has been reprinted in the USA and Denmark several times.

In a 'Graphics Yearbook' where the poster was reproduced, the accompanying text explained, probably on the basis of my inadequate information, that the poster had the aim of proclaiming that Dizzy Gillespie and the Montmartre neighbourhood in Paris both went in for exchanges of jazz musicians.

And no doubt they do ..."

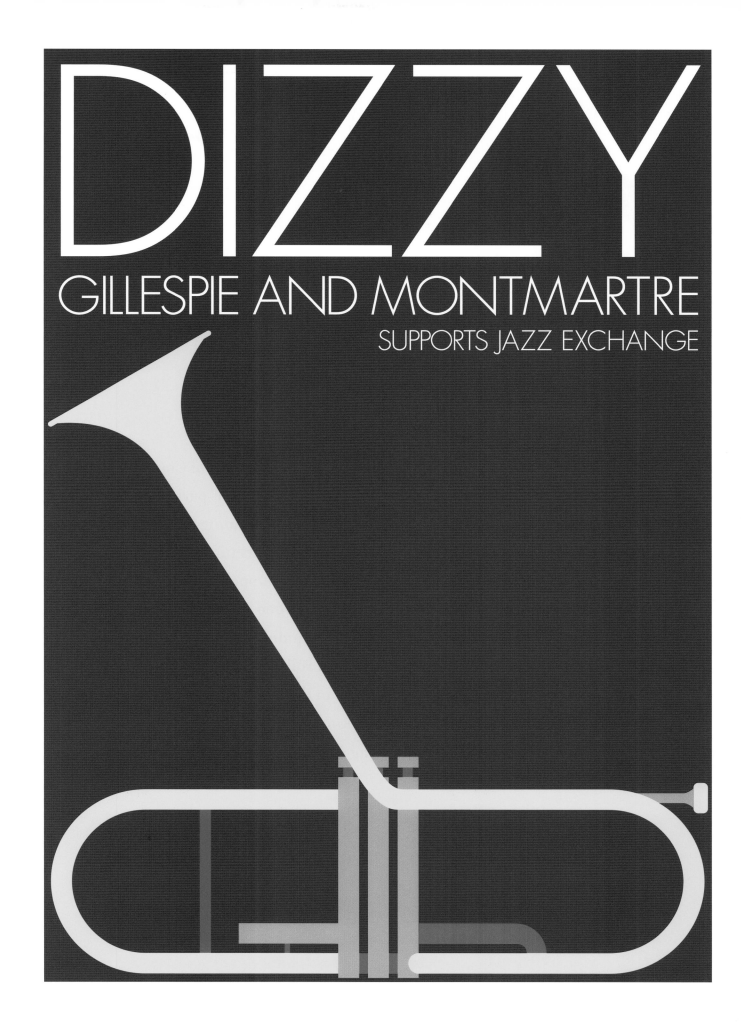

OWN EXHIBITION JAPAN

LOGO <
1992

**DYREHAVSBAKKEN
AMUSEMENT PARK**

POSTER >
70 x 50 CM
1988

" Dyrehavsbakken, north of Copenhagen, claims to be
the world's oldest amusement park. It has, high above
the treetops of the surrounding forest and the beautifully
clamped-together architecture of the low booths, its
own almost equally clamped-together and equally old symbol:
a roller-coaster of wood where the carriages squeal with
pleasure as they rumble round and high up and far down.
Perhaps the old roller-coaster is no longer the most
sophisticated in the world ... but the symbol is unbudgeable
and classic, and when the darkness descends and there's still
a rumbling up there in the evening sky, it's sheer magic ..."

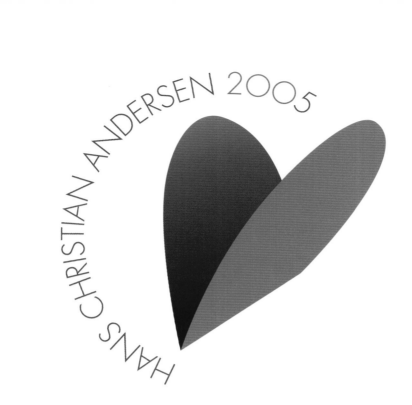

HANS CHRISTIAN ANDERSEN 2005

LOGO ∧
2003

ELION & PAJKRT BOUWEN HOLLAND

POSTER FOR CONTRACTING FIRM >
125 x 90 CM
1982

" The difficult thing about
Hans Christian Andersen material
is that it's written so well and in most cases
drawn so badly.
Under his pen the images blossom, rich
and wild and wonderful, and under the
artist's it all dries up into a far-too-simple,
poor reduction.
My logo for Hans Christian Andersen's
bicentenary was long in coming.
I tried Little Ida's Flowers hoping to get the
natural diversity of the bouquet for free.
I tried Thumbelina's butterfly, to capture
its fluttering brilliant flight, and I tried
making the book where it's all already
written so clearly spread its pages in the
flight of the swallow and take off from my
flat paper. And then the whole process
stalled, until a heart I had cut from a piece
of paper to try to fold a meaning out of it
unfolded itself on the table. All at once
it became flower and bird and book and
butterfly, and still Andersen's generous
heart on its way out into the world he has
already conquered. Now, in 2005, 200 years
after his birth, it will conquer again and
again!"

elion & pajkrt bouwen

SKETCH

2001 ∧

LES 10 CRUS DU BEAUJOLAIS

POSTER • >
100 x 70 CM
2003

" In the Beaujolais District's sea of wine ten appellations are entitled to a cru classification. Of these, perhaps four are 'the famous ones' and the rest are thus – irrespective of quality – lesser known. After wine from all parts of the world began to crowd the coddled French wine labels from the shelves, the lesser-known labels were of course the first to feel the pinch, still irrespective of quality. What we are talking about here is visibility or invisibility. To help visibility and memory the big Beaujolais producer Georges Duboeuf commissioned a poster that wasn't necessarily meant to advertise the excellence of the wines in the normal sense, but to remind us of them, to give them visibility and hang like a wine list in as many places and for as long as possible. I drew this wanton corkscrew which, funnily enough, once furnished with the names of the ten crus, came to look like one of the wonderful route maps of the French wine-growing districts, more poetry than geography.
A route through Beaujolais, swinging in high spirits along all the ten curves that open the wine ..."

EGE ART LINE

LOGO ∧
1988

POSTER >
100 x 70 CM
1988

“ Ege is a big carpet factory that plunged into the art world with great appetite. They thought that there must be images which, kept within the confines of the carpet, could create an 'art line', a collection with more visibility and dynamics than the pattern designers' endless variations over long, long lengths could sustain. It's both true and not true. Some things are well suited and create sweet harmony and synergy; some things are less suited, and some poor carpets have to lie low, floored by dramatic collisions.

Art plus industry? Match, mismatch or mishmash? It has to be tried!”

KUNST + INDUSTRI = ART LINE
HISTORIEN OM ET SAMARBEJDE

EN INTERNATIONAL KUNSTUDSTILLING PÅ HERNING KUNSTMUSEUM I ANLEDNING AF EGE TÆPPERS 50 ÅR. OKTOBER 1988

SKETCH <
1994

POSTER >
100 x 70 CM
1994

" The wisest know everything.
The next wisest know where to look it up. Oddly enough
it's called asking silly questions when it's the wisest thing
you can do – the wise owl knows that.
So one symbol is firmly perched on the other!"

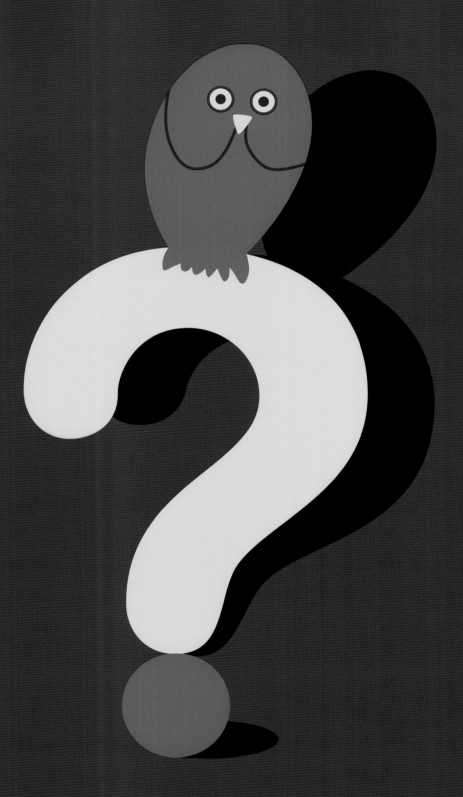

DEN STORE DANSKE ENCYKLOPÆDI

DANMARKS NATIONALLEKSIKON

KTAS TELEPHONE COMPANY

POSTER <
100 x 70 CM
1980

FANØ GOLF LINKS

POSTER >
100 x 70 CM
2001

" Often it's the letters that have to take the flak. Language is patient and the individual letter, which rarely means anything by itself, is almost defenceless.

Actually I didn't know what 'golf links' means; but I found out that it usually means a golf course that's almost pure landscape and near the sea and you have to play over dunes and sand and shore grass and around rival rabbit-holes.

I knew well enough what Fanø is – it's almost the most watery of all the Danish islands, so I had to remove the sea barrier from a Danish 'Ø' (which means 'island') and make a hole in one ..."

FRANK LLOYD WRIGHT·THE GUGGENHEIM MUSEUM

POSTER <
100 x 70 CM
1988

POSTER • >
100 x 70 CM
2003

> " In 1988 I designed a poster for the
> Guggenheim Museum in New York.
> What had fascinated me about the building
> was the split-second in which I imagined the
> idea for the building took form or became
> clear or struck home or popped up in the
> head of the architect Frank Lloyd Wright
> under his characteristic hat.
> And more generally, a fascination with how
> ideas appear and from where.
> It struck me many years later that I could
> perhaps have taken the same story or the
> same question a step further and achieved the
> same dizzying feeling simply with the spiral
> of the building which disappears up into the
> thin air of all ideas.
> And that seems to be the terrible and
> wonderful thing about ideas both good and
> bad ... now you see them, now you don't,
> and they never give you any peace ..."

THE**GUGGENHEIM**NY

VIBO

LOGO FOR HOUSING ASSOC. >

1981

UN YEAR OF VOLUNTEERS

POSTER >

100 x 70 CM

2001

❝ Swallows are such virtuosos, flying so far and so high and so low and so close together, that as symbols, gathered in a peaceful formation, they could carry the UN's very important volunteer initiative far and wide.❞

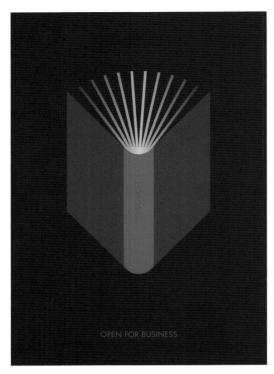

OPEN FOR BUSINESS

PETER GROSELLS ANTIKVARIAT

POSTER <

2003

ANTI-NAZI DAY 29TH AUGUST

POSTER >

140 x 100 CM

1993

" Grosell is a prominent antiquarian bookseller.
He really knows something about it, and sparkles like the
sun at each find. He also sparkles on each sale and
is as enthusiastically *open for business* as his best book ...
Flying high in his basement!"

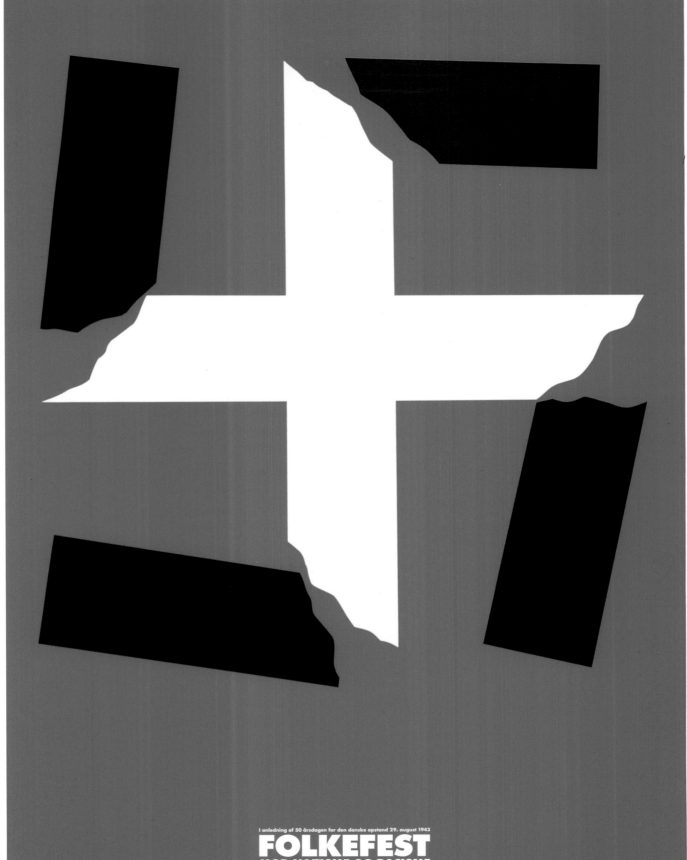

I anledning af 50 årsdagen for den danske opstand 29. august 1943

FOLKEFEST
MOD NAZISME OG RACISME
29.AUGUST

Rådhuspladsen kl. 11.30 - 13.00 og på S-øren kl. 14.00 - 19.00
Arrangeret af Aktive Modstandsfolk og Fagbevægelsen mod Racisme

**INTERNATIONALE BAUAUSSTELLUNG
EMSCHER PARK ESSEN**

LOGO • ∧
1990

DUKE ELLINGTON CENTENARY

POSTER FOR BANG & OLUFSEN >
120 x 80 CM
1999

" Bang & Olufsen make systems that reproduce good sound. Duke Ellington created the best. Born in 1899, he, or rather the whole world he left behind, celebrated his 100th birthday in 1999. Bang & Olufsen participated very visibly and very audibly in the big international celebration of the day and the year and the work.

I suggested that a duo, bass and piano, should record some of the Ellington numbers he himself had recorded in 1939 and immortalized with his young bassist Jimmy Blanton in the duo's compact chamber-tight form.

The bassist this time went more or less without saying, since it was a Danish initiative and a Danish advertiser: it had to be Niels-Henning Ørsted Pedersen, and he picked out the American pianist Mulgrew Miller as his partner in this musical adventure. And then I couldn't resist the duo form and Bang & Olufsen's combination of technology and high-quality sound.

25,000 CDs and a world tour later we felt we had made our contribution to the great celebration ... The poster was almost the least of it. The music is still with us!"

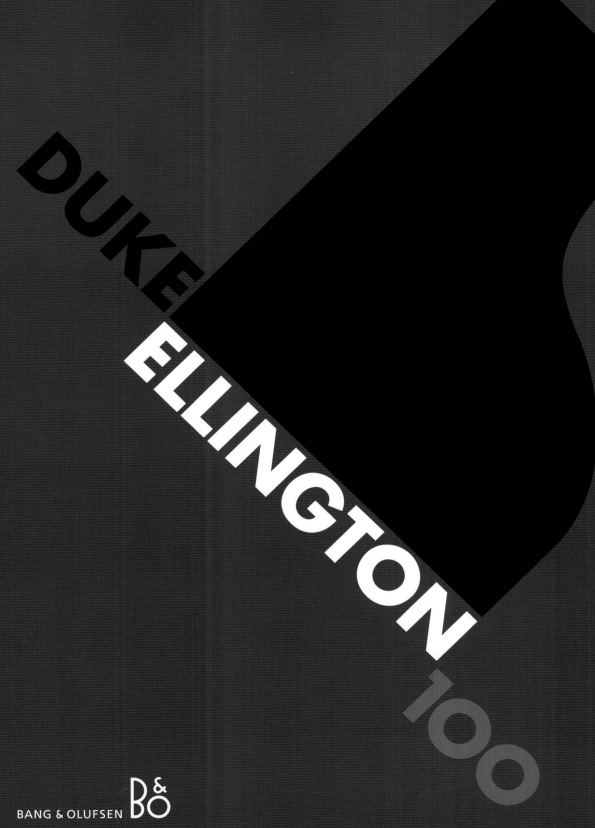

1899 - 1999

DUKE
ELLINGTON 100

BANG & OLUFSEN B&O

KIELER WOCHE

LOGO • /\

1996

CLEAN WATER

POSTER FOR DANCHURCHAID >

100 x 70 CM

1998

❝ Kieler-woche is a huge annual regatta.
The posters and graphic signals surrounding a regatta
are quite naturally almost always sails and flags
and waves and buoys etc.
I tried to make a sail appear without actually drawing
the sail ... just let it be formed from the strong colours
of the signals.
A 'non-sign' instead of a sign ...❞

FREDERIKSSTADEN
1749 1999

Amalienborg-kvarteret fylder 250 år · Udstilling: **GUD KONGE BY** · **Det danske Kunstindustrimuseum**
Kulturfestival · Chr. VII's Palæ · Amalienborg Museet De Danske Kongers Kronologiske Samling · Dehns Palæ
Frederiks Hospital · Lindencrones Palæ · Marmorkirken · Odd Fellow Palæet · Frederiksstadens Gallerier
Medicinsk-Historisk Museum · Bernstorffs Palæ · Frederik V's rytterstatue · Det Gule Palæ · Chr. VIII's Palæ

STAN GETZ

RECORD COVER • <

1981

JAZZ CLUB MONTMARTRE COPENHAGEN

POSTER >

120 x 80 CM

1981

" Stan Getz asked me to design a record cover.

To draw a good likeness of him from my own photo, and so that I wouldn't be stealing a silhouette from others, I went to London, where he was to play at Ronnie Scott's Jazz Club. I crawled around in the dark in front of the stage with a fast black-and-white film and no flash, of course, hoping I could glimpse and capture the profile of man and sax that could be a recognizable, distinctive signal. One that with the right cropping could be reduced to the three colours red, blue, and yellow to which I incidentally think that anything, with a little luck and firmness, can be reduced.

Getz liked the draft version, but the producer who made the decisions didn't, and wanted a photo of man and sax, so I should probably have used flash instead of standing with a square drawing.

I used it on an oversized poster for Jazz Club Montmartre in Copenhagen and later, in a smaller format, on a tourist poster for the city, which according to the tourist office is The Jazz Centre of Europe.

In several contexts I've tried to give the Little Mermaid a rest, precisely because I think it's such a good tale ...

Getz was an alternative."

JAZZ
MONTMARTRE COPENHAGEN

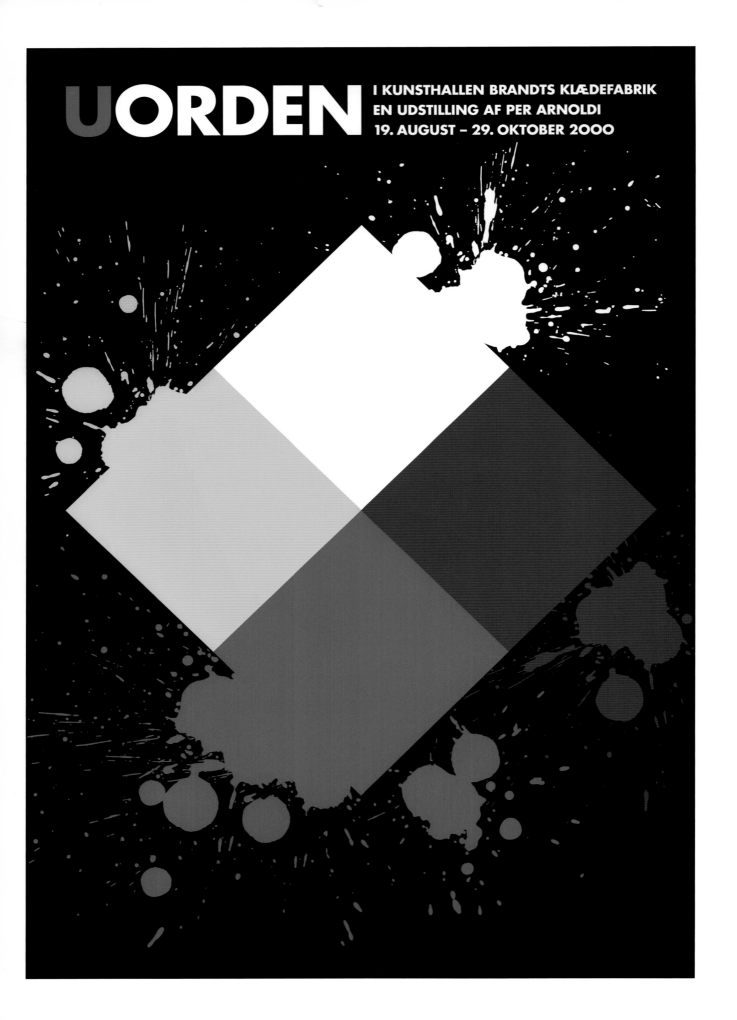

UORDEN I KUNSTHALLEN BRANDTS KLÆDEFABRIK
EN UDSTILLING AF PER ARNOLDI
19. AUGUST – 29. OKTOBER 2000

DET RENE VAND

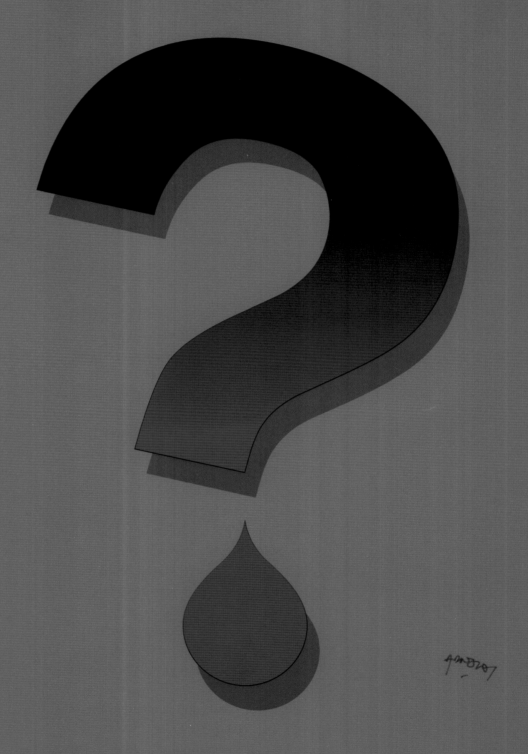

FOLKEKIRKENS NØDHJÆLP

KILDEGAARDS GYMNASIUM

LOGO ∧
2003

FREDERIKSSTADEN 250 YEARS

POSTER >
100 x 70 CM
1999

" Kildegaards Gymnasium is a private upper secondary school that arose out of another private boys' school where I actually went myself for twelve years ... and rising out of something isn't a bad image for a *kilde* (source or spring)!

All the same, even a dubious pun can give nourishment and life to a relevant symbol for a new logo for Kildegaard.

The school's history is lost in – or based on, or suffers from, or whatever – a 133-year past, from Countess Moltke's Girls' School via Østersøgade Gymnasium and now Kildegaard.

So there was some business about the Moltke family heraldic arms with an escutcheon and black grouse, but should there still be? This was the question.

Well, if everything was made new, where would everything go?

So I thought that the shield, now that the bird had flown – and was extinct anyway and therefore not so potent or present an image unless stuffed in the school collection – could take the plunge into a neo-heraldic springing fountain.

Potent and fresh and optimistic and fruitful and inexhaustible and whatever else you could want from a good school. So the shield was given new life and a modern tilted-square frame, curiously and harmoniously set in an element which like the fountain and the shield itself is created from four identical elements."

**CLINICAL UNIT FOR
PREVENTION OF DISEASE**

LOGO >
1999

RECYCLING

POSTERS FOR BILLUND TOWN COUNCIL >
100 x 70 CM
1991

"" It wasn't intentional ... but it's
really quite interesting that when
you isolate one thing, as in this series of
recycling posters for Billund Town Council,
it changes character.
It is precisely the essence of the poster
and its essential linguistic content to choose
one symbol, focus on one motif, select one
thing as the 'key word'. Then when you
place this one thing right in the middle and
give it full focus, what was once garbage,
and was meant to be interpreted as garbage,
becomes recycling, almost so beautiful in
itself that the poster is more of an argument
for preservation ... and that wasn't really
the point.
The visual artists have known it for a long
time:
Garbage is good!"

OLIE + KEMIKALIE AFFALD
OMHU

PAPIR AFFALD
GENBRUG

METAL AFFALD
GENBRUG

PLAST AFFALD

GENBRUG

OLE HOLST ARCHITECT COPENHAGEN

LOGO ∧
2003

DANISH ARTHRITIS ASSOCIATION

POSTER >
100 x 70 CM
2001

❝ Several years ago I designed a jumping-jack for
the Danish Arthritis Association where little arrows pointed
to the joints that must be painful for all jumping-jacks
with arthritis.
That way one could imagine for oneself the problematical
number of movements!
And now, the second time, I thought again that an alphabet
of the possible and impossible movements you could
dream of inside and outside the nightmare of arthritis could
tell the same story."

 Gigtforeningen

CENTRUM FOR RYG-, LED- OG MUSKELLIDELSER

www.gigtforeningen.dk

KOLDING CITY COUNCIL CARE QUALITY

LOGO ∧
2000

GLASS ART AND CRAFTS

POSTER >
100 x 70 CM
1996

" The word ballet always comes to mind when you want to describe the glass artist's magical, perilous, glowing, sparkling working process. And that isn't so strange, for it really involves dancing and shaping it now and here and while it's hot, and also now and then whirling it around in the air until the glass lands where it should, malleable and still flexible and perhaps miraculously as – a glass ..."

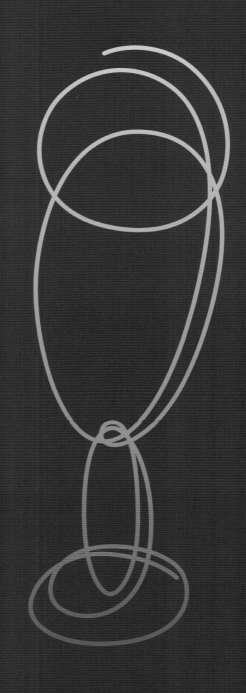

GLAS · KUNST & HÅNDVÆRK
23. JUNI - 1. SEPTEMBER 1996 · MANTZIUSGÅRDEN + BIRKERØD RÅDHUS

V. S. LARSEN

LOGO FOR PAINT COMPANY <
1982

"TWO DAYS FROM SATURDAY NIGHT"

POSTER FOR THE THEATRE FIOLTEATRET >
COPENHAGEN
140 x 84 CM
1993

" The stage is almost in complete darkness.
A faint, narrow sliver of light falls from a door slightly ajar
into a dark empty room.
A young couple has answered an advertisement about
a flat for rent and come up the stairs ... they step hesitantly
into the dark and on to the stage and into the text.
The play can begin ... and never ends.
This dimly lit random ad was the poster for Jokum Rohde's
debut play ... just as random as the play's carefully and eerily
precisely placed jigsaw pieces ..."

To dage ud fra lørdag nat

Af Jokum Rohde

**Baard Owe · Birgitte Simonsen · Henrik Køhler
Instr. Giacomo Campeotto**

Fiolteatret **5.-27. november**
Halmtorvet 9 Kbh. V · 31 24 00 77

HOTEL LA PERLE PARIS

LOGO ∧
1993

POSTER • >
100 x 70 CM
2003

" The story is a bit complicated ...
An old worn-down hotel of dubious reputation in the Rue des Canettes in the 6th arrondissement in Paris was to be totally rebuilt and refurbished – and this was a building with elements from the sixteenth century.

Easier said than done, yet very beautifully done. A concealed interior yard was incorporated as a peaceful courtyard garden, and the blank wall of the neighbouring property, which was equally in need of repair, now became a highly visible element from all five floors of the bright, newly painted hotel.

I was asked to decorate the high, windowless but still irregularly drainpiped wall. For that purpose I 'invented' a kind of giant stencil with a cut-out wallpaper-like floral motif that we could dab right across the high wall on the large scale ... an ordinary pattern, a discreet variation on an uneven surface.

Turning the focus on one thing to obscure something else is another good old trick – and they're often the best.

The sketch was promising and was approved, and the scaffolding was on its way when it turned out that according to French law you can repair your neighbour's wall but not decorate it, not even on your 'own' side.

The project was abandoned, and the little flower survives as the logo for a hotel that in fact came to be called La Perle – and you might wonder about that if you hadn't heard the whole story.

And so in the end it all came together anyway in a poster for the hotel, where the flower stencil's holes cut exactly the best bits out of the best neighbourhood in Paris."

HOTEL LA PERLE

★ ★ ★

14 RUE DES CANETTES · 75006 PARIS

LONDON PHILHARMONIC ORCHESTRA
+ KURT MASUR 2000 / 2001 SEASON AT THE ROYAL FESTIVAL HALL
FULL DETAILS FROM THE LPO HOTLINE 020 7840 4242 OR
FROM THE LPO WEBSITE WWW.LPO.ORG.UK

LONDON PHILHARMONIC ORCHESTRA

POSTER <

100 x 70 CM

2000

SAN FRANCISCO SYMPHONY

POSTER • >

100 x 70 CM

1976

" The poster was never used. The harp wasn't
a symphonic symbol, was the reason given.
But I couldn't escape the attraction of precisely that
– the harp, which with all its strings, I thought,
included the whole breadth of the orchestra and
a rainbow of timbres ..."

SAN FRANCISCO SYMPHONY

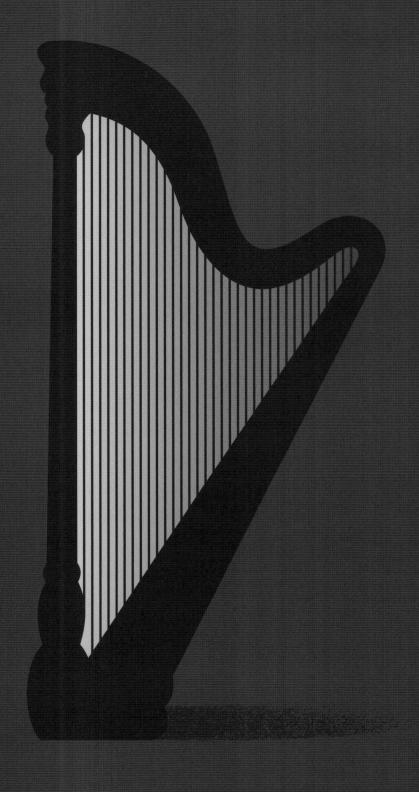

MUSICAL DIRECTOR HERBERT BLOMSTEDT

WORLD ARTS FORUM GENEVA

LOGO ∧
1993

HVIDOVRE THEATRE

POSTER >
100 x 70 CM
1976

" The masks have pursued me for many years.
They look back in the same odd way as when the position of
the windows on a gable suddenly transforms a far-away
house into a staring face ... or when an electric socket on the
wall begins to gawp at you.
You only have to stick in two dots and the whole house, or here
the whole paper, turns into a mask that wants your attention ...
Hvidovre Theatre asked for an image poster that was to stare
at the public in the period when the theatre had nothing on.
The 'puzzle picture' also has a built-in mechanism which
means that you can only perceive one of the mouth positions
at a time ..."

HVIDOVRE
TEATER

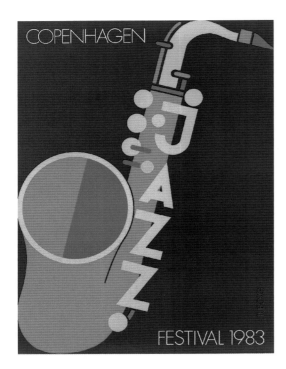

COPENHAGEN JAZZ FESTIVAL

POSTER <

80 x 60 CM

1983

MINGUS

POSTER • >

100 x 70 CM

2003

❝ I don't know what Mingus does to his bass, and
I don't know either whether the bass is quite clear about
what he's up to ... but I know what he does with the
music and the rhythm and the pulse of the public who are
carried away into his wild universe.
No kid gloves on these fingers – the breath races, there
are shouts of jubilation over the masterful touch or knack
that can knock spots off the space ... as long as it doesn't
bring the house down!"

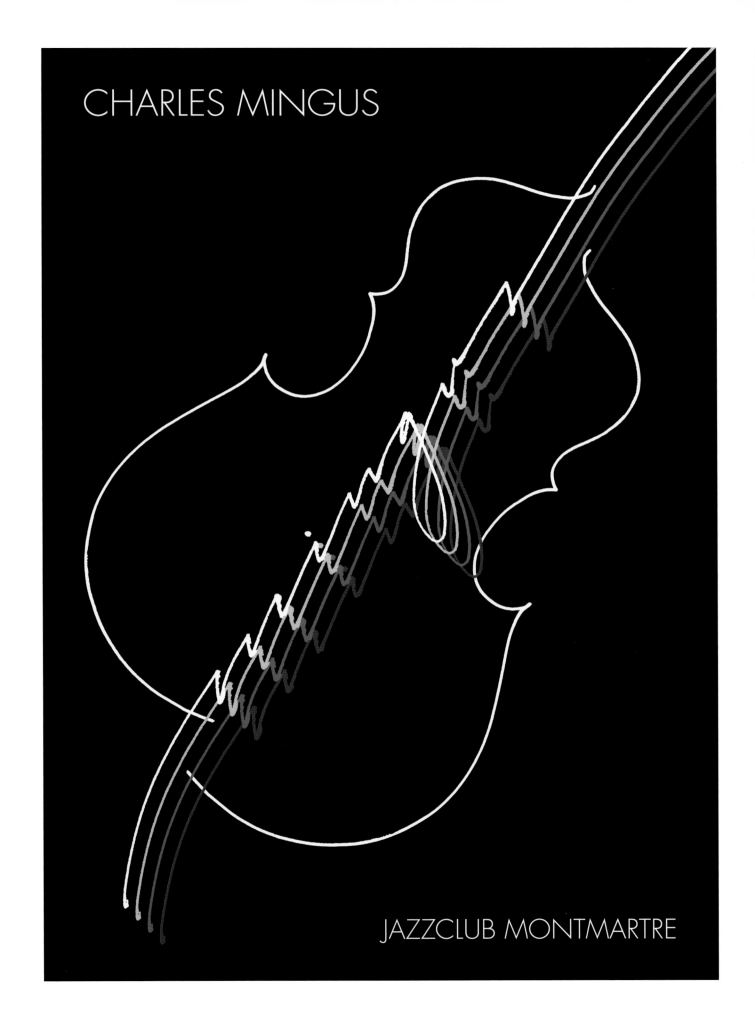

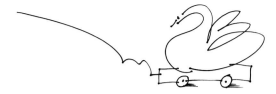

SKETCH

1982 /\

LINCOLN CENTER NEW YORK

POSTERS FOR THE PERFORMING ARTS >
OPERA / THEATER / DANCE / FILM / MUSIC
90 x 60 CM
1982

 The series of posters for the
Lincoln Center in New York with
the five arts – opera, theatre, dance,
film and music – was supposed to hang as
a collected and connected group, as they
do here.
A series is a teaser. It's impossible to get
five ideas up to the surface at the same
time.
They switch places. The first idea, the
simplest and easiest and apparently
glowingly and glaringly obvious, loses its
lustre when it is upstaged and sidelined
and disappears into the wings ... the
challenge consists of not leaving anyone
out of the limelight.
The opera was the most difficult. Parody
was a built-in risk factor. Overlong Wagner,
overlong pigtails, overlarge bosoms,
too many helmets, "Flee! Flee!", spears
and lightning and thunder ...
I suggested as a prop, as a toy, as a
disarming joke, the set motif that is at the
core of the old Siegfried joke. The swan at
the back of the set on the little cart. The
man who pulls the string pulls it too early,

before Siegfried has done singing and as
he is gasping for breath and is supposed to
go on board and drive out in style.
The swan disappears and Siegfried sings
"Oh when oh when does the next swan
leave?"
The joke is so old that it's perhaps both
an apocryphal tale and a worn-out cliché,
but the drawing was very clear. Blue
background, white swan, a little cart,
brightly coloured, slightly too conspicuous
wheels. String stage left.
Everyone loved it until someone who didn't
know the story saw it and didn't understand
it and had to have it explained.
His lethal comment – 'I don't like inside
jokes' – decided the matter. He was right.
The point was incomprehensible if you
didn't know the story, and if you did, why
hear it again?
Clichés aren't inside jokes. Clichés, of
the kind that can be used for posters, are
outside jokes, everyman's, accessible,
decipherable, which are then polished up,
told again, as if for the first time, so you
prick up your eyes. Exit the swan.

So then I thought it would be amusing
for an art of the ears to use the eyes and
draw a pair of *opera glasses* and play on
the little paradox – see or hear or hear
and see."

OPERA

THEATER

LINCOLN CENTER FOR THE PERFORMING ARTS

FILM

DANISH DACHSHUND CLUB

LOGO • ∧
1999

GLASS AND POETRY

POSTER FOR EBELTOFT GLASS MUSEUM >
100 x 70 CM
2001

" As mentioned before, it's always a bit embarrassing if you have to explain your points ... not to mention helping a sick joke on its way! And now and then the point is simply so unfamiliar that even though it's valid enough in the given context, it can no longer be grasped and interpreted.
When I was asked to mount an exhibition of selected work from the Ebeltoft Glass Museum's large international collection of widely varied glass art, I couldn't help remembering the 'Jazz and Poetry' genre ... and then calling it Glass and Poetry and surrounding the exhibited works with wall-sized poems printed in the original language on large sand-blasted glass sheets. I think I was the only person, forty years after Jazz and Poetry, who still associated the two titles ... and so I resorted on the poster to the shortest poem:
The right word, here written with the red hot filament."

Udvalgte værker fra den permanente samling iscenesat af Per Arnoldi

og poesi

GlasmuseetEbeltoft ♂

udstillinger
galleri
butik
værksted

åbningstider
dagligt 10-17
juli dagligt 10-19

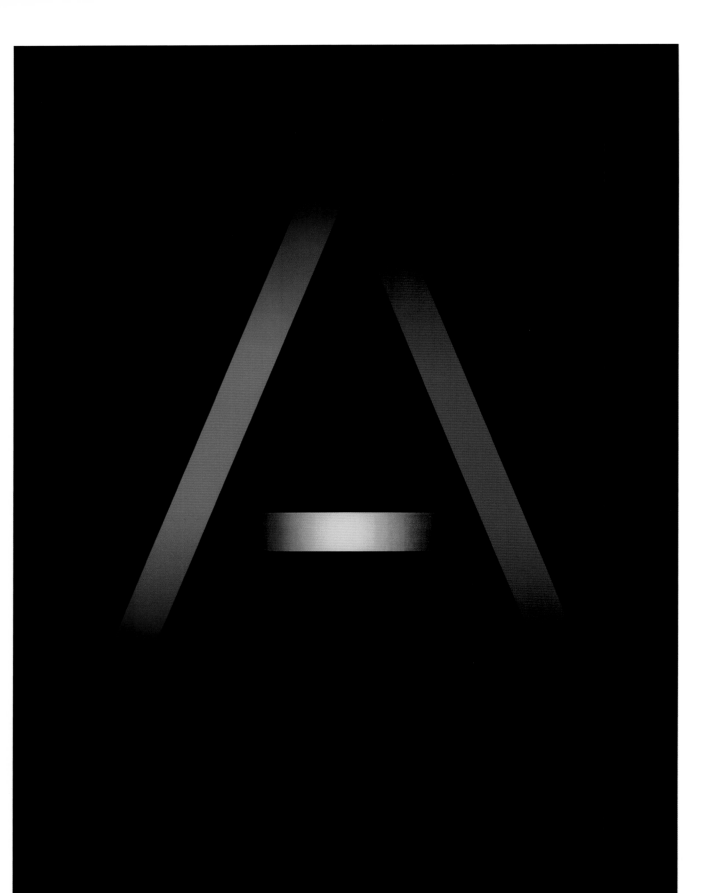

PER **ARNOLDI 100 PLAKATER** ETC. **ORDRUPGAARD** KØBENHAVN
3. MARTS – 14. MAJ 1995 TIRSDAG · FREDAG 13 – 17 LØRDAG OG SØNDAG 10 · 17 VILVORDEVEJ 110

DE DANSKE SPRITFABRIKKER

SKETCH <
2003

POSTERS >
70 x 50 CM
2003

" Of course it's always good when a
concentrated graphic articulation
and message offer a quite obvious
possibility for economically manageable
production. Or, more directly, when the
best solution means the least expensive
realization.

Just as you can't jazz up a weak idea into
something with 500 special colours and as
much lacquering as you like, you can't
force invalidatingly lean economics on a
complex idea.

In this case I was lucky and the idea was
as simple and transparent as the schnapps
advertised: blue for cold and red for warm
and two posters, so that any participant in
the wonderfully endless discussion of the
right temperature for the drink can
have his quite simple 100% proof of the
rightness of his own view printed ..."

AKVAVIT

KOLD I VARMEN

AKVAVIT

HAMLET PRIVATE HOSPITAL

VIGNETTE <
2001

ISS 100 YEARS

POSTER >
100 x 70 CM
2001

" The hourglass as a vignette for the private hospital
Hamlet has to do with waiting time ... more precisely with the
absence of waiting lists.
So I thought about whether it was frightening that time tends
to run out like sand – and then in that context ... but after
all it's good enough as a symbol, because it doesn't necessarily
have to run out ... it can be turned around!"

CAREPARTNER

FACILITY SERVICES

FOOD SERVICES

AVIATION

DAMAGE CONTROL

1901 (ISS) 2001

SCANPROPS

LOGO　　　　　　　　　　　　　　　∧
1992

HEADHUNTING

POSTER　　　　　　　　　　　　　　>
70 x 50 CM
1985

"　There's an expression about going after the man instead of the ball, which came to mind when the poster for the headhunting firm JB International was to be designed. But then the headhunting idea doesn't exactly evoke positive images. Then the legendary Swiss figure William Tell occurred to me, with his accurate master-shot at the apple on his son's head, as a more acceptable symbol for those who necessarily have to recruit the right man and hit their mark. After all, it's an advertising poster ..."

HEADHUNTING

LOGO

1999 • ∧

OCTOBER '43

POSTER >
100 x 70 CM
1985

"The poster for the fiftieth anniversary of the rescue of the Danish Jews and their escape to Sweden in October 1943 couldn't be made simple enough.

The story is big enough and the myth even bigger.

So just the simplest devices: the from-here-to-there of escape. The horizon line of the Sound between Denmark and Sweden and the Star of David, tapering towards a direction, a way out.

That this very simple image also came to contain the railway lines which in the terrible reality of many other stories and holocausts became the image of the ominous road to annihilation was not intentional.

I hadn't designed that interpretation into my symbol ... but it was already there, indelibly, in the story."

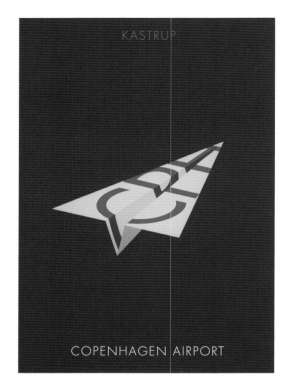

COPENHAGEN AIRPORT KASTRUP

POSTER • <
80 x 60 CM
2000

POSTER >
175 x 118 CM
2000

" Copenhagen Airport in Kastrup was honoured as Best Airport in the World 2000, and celebrated with a poster. I thought I should emphasize the idea of port or haven, and surely nothing is more comforting, when you're safely down and home, than a heart-felt, warm welcome from a friendly wind-sock ..."

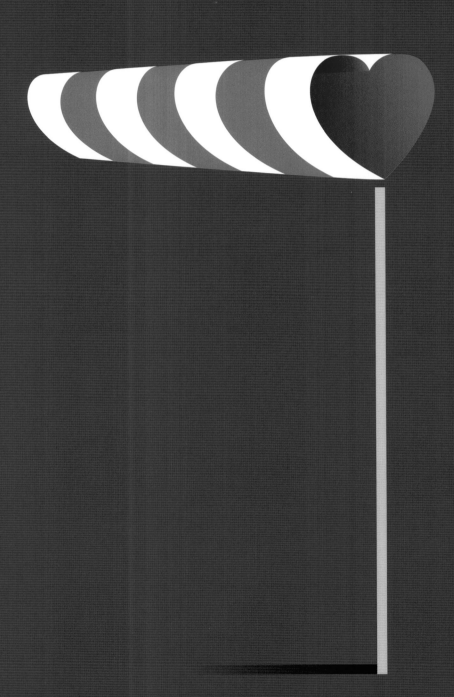

SOLAR ENERGY

LOGO FOR SEGMENTA • HAMBURG ∧
1998

KEVI

POSTER >
100 x 70 CM
1976

 " The Kevi office chair is a classic and so well known that I could colour it as crazily as I liked without it disappearing. The only thing that disappeared on purpose, yellow on yellow, was the firm's logo in the top middle of the poster, because we wanted to be as discreet as possible.

The chair is manufactured on license in the USA by Herman Miller, who had his own impression printed with his own logo and in red so it wouldn't disappear. Discretion is a European hang-up."

TOOLTOYS

TOOLTOYS

LOGO FOR DANISH DESIGN CENTRE /\
1996

THREE BALLETS

POSTER FOR THE ROYAL THEATRE >
COPENHAGEN
100 x 70 CM
1989

" Tooltoys is a theory and an idea
and was an exhibition and a book
that demonstrated and asserted the
element of play which, even in the most
functionally sober tools, makes some
designs stand out from others and perhaps,
claimed the theory, was the real reason
for the success of this particular product.
The rounded toy-like shape of the
Volkswagen is an example, interestingly
enough, from a very unplayful period and
culture, one would think ... So I gave the
two o's of 'tools' a sidelong glance, discreet
but sensible, at 'toys'.
Form follows function, but we choose
according to quite different, wonderfully
irrational and perhaps playful criteria!"

DET KONGELIGE TEATER
1989

TRE BALLETTER

FRANCE/DANCE
WILLIAM FORSYTHE

MANHATTAN ABSTRACTION
ANNA LÆRKESEN

FÊTE GALANTE
IB ANDERSEN

RED

BLUE

YELLOW

ART POSTER GALLERY

Ernst Friedel Maischein
Gaustraße 62a
D-6702 Bad Dürkheim
Telefon (06322) 66534
und (06233) 53442

Plakate von Per Arnoldi
28.6.–25.7.1987

TEMPO

POSTERS FOR >

THE TEMPO DEPARTMENT STORE SWEDEN

200 x 350 CM

1983

" For a fortnight in the summer of 1983 eight giant posters coloured the whole of Sweden. The department store Tempo and the bureau Arbman Stockholm had asked for a series of motifs that could decorate the street space and the urban scene, mentioning certain specified groups of products or individual products, without necessarily showing them.

Liberating and obvious. If you want to sell a bikini and draw a bikini and write a bikini, you have perhaps wasted an opportunity to work at two levels. One in the picture and one in the text. So here I had the idea: when the sun appears you can of course buy the bikini from Tempo; and when the rain comes, the books can be bought in the same place. The bigger the pictures you make, the less you need to put in them. A lot of yellow is more yellow than less yellow.

The job of decorating the city for a fortnight suggested completely clear surfaces that would catch the eye from far away.

We were trying to purify the urban scene at the same time as we were filling it up as effectively as we could."

NÄR SOLEN VISAR SIG,

FINNS BIKININ PÅ TEMPO!

NÄR LÅGTRYCKEN ANLÄNDER,

FINNS BÖCKERNA PÅ TEMPO!

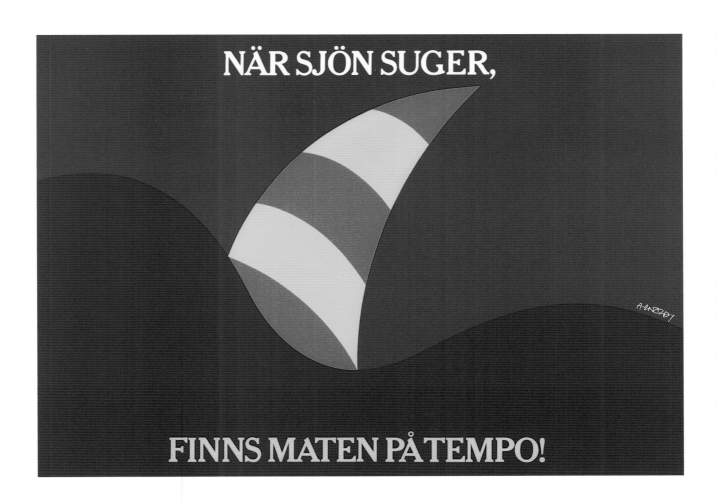

NÄR SJÖN SUGER,

FINNS MATEN PÅ TEMPO!

NÄR ÄNGEN BLOMMAR,

FINNS VASERNA PÅ TEMPO!

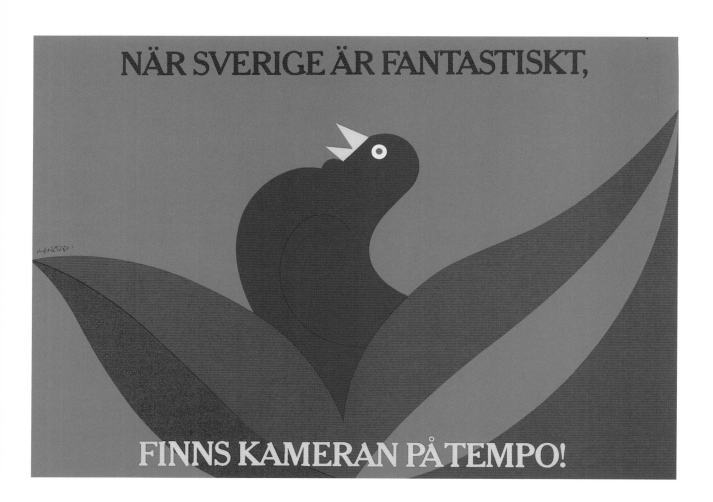

NÄR SVERIGE ÄR FANTASTISKT,

FINNS KAMERAN PÅ TEMPO!

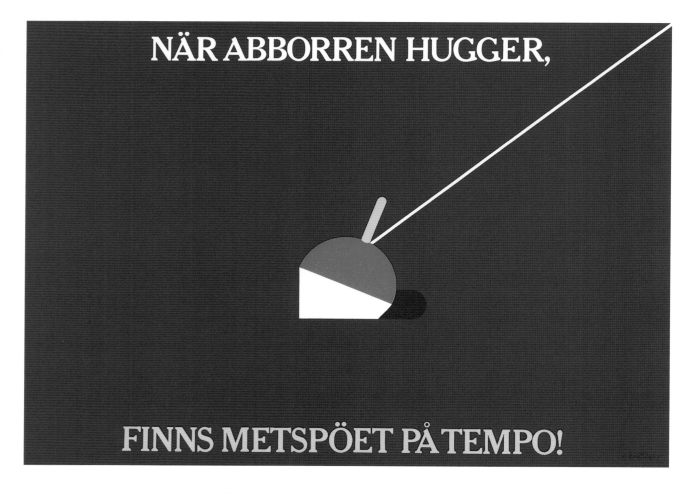

NÄR ABBORREN HUGGER,

FINNS METSPÖET PÅ TEMPO!

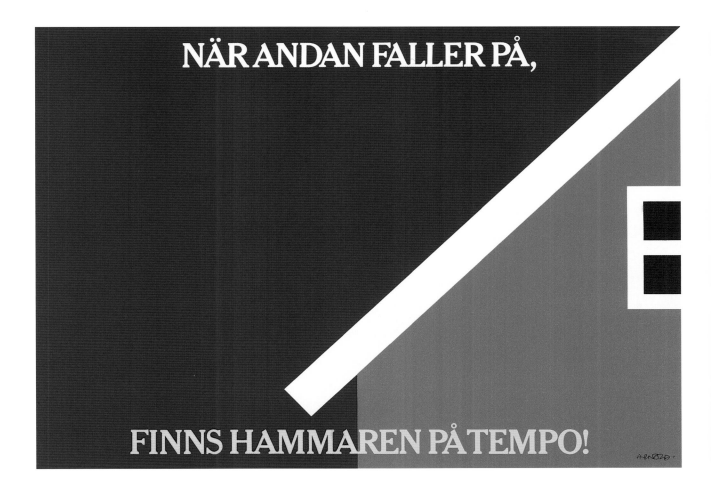

NÄR ANDAN FALLER PÅ,

FINNS HAMMAREN PÅ TEMPO!

NÄR DU SAKNAR MUSIKEN,

FINNS RADION PÅ TEMPO!

Statens Museum for KUNST

STATENS MUSEUM FOR KUNST

LOGO FOR ∧
THE DANISH NATIONAL GALLERY OF FINE ART
1993

KOSOVO

POSTER / ADVERTISEMENT >
FOR UNITED NATIONS •
100 x 70 CM
1999

" The Kosovo poster/advertising campaign doesn't need a lot of words to explain it. The words, the concepts and the lives of thousands of hard-hit people were falling apart horrifically.
The little empty white space below the lowest, folded right-hand corner was the free space for the campaign sponsor that we never found ...!"

HOME
FAMILY
HEALTH
HOPE
FUTURE

**HELP US
HELP
THE REFUGEES FROM
KOSOVO
USA FOR
UNHCR**

UNITED NATIONS HIGH COMMISSIONER FOR REFUGEES. CONTRIBUTION FOR KOSOVO. C.P. 2500, 1211 GENEVA 2, SWITZERLAND HTTP: // WWW.UNHCR.CH

FOR INTERNATIONAL MONEY TRANSFERS: CITIBANK (SWITZERLAND), ZURICH. UNHCR ACCOUNT NO. 343 140

LE PETIT ÉCOLIER

LU FRANCE

POSTER <
100 x 70 CM
1994

LONDON UNDERGROUND

POSTER • >
100 x 70 CM
2003

" London Underground has one of the world's best, strongest logos. It is demanding company. In this poster, they wanted to link a given selection of leisure activities with the options for getting there that the trains could offer.
I tried, trembling in awe before the client's logo, to make the respective activities and sports 'do' what they are called – to make a start on what one hopes are attractive activities as far back as the platform where the poster was to hang and the train was to come rooooooooolling in ..."

ROOOOOOOOOOOOOOOOOOOOLLER BLADING

SALSA DANCING

TAI CHI

YOGA

MEDITATION

CYCLING

KICK BOXING

ICE skating

VIA

**WARM VALLEY STUDIO
WASHINGTON DC**

LOGO ∧
1995

**RESTAURANT LUMSKEBUGTEN
COPENHAGEN**

POSTER >
100 x 70 CM
2003

" Lumskebugten means a secret, snug and sneaky
cove and that is how the restaurant is situated, marvellously
quiet and calm on the Esplanade right down by the water
and the old gate from the eastern waterfront of the city –
a restaurant with a firm anchorage in a living sea of nostalgia.
Which, as we know, ain't what it used to be!"

RESTAURANT LUMSKEBUGTEN

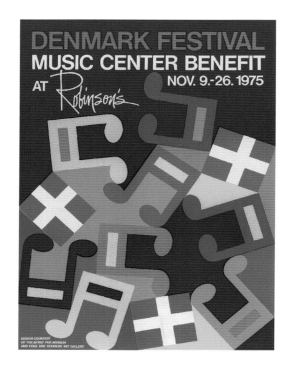

ROBINSONS LOS ANGELES

POSTER <

100 x 70 CM

1975

MAKE MUSIC WELCOME SUMMER
NEW YORK

POSTER >

100 x 70 CM

1989

❝ It may be true that one swallow doesn't make a summer, so here's a whole flock of them over New York in the summer of 1989, and they clearly know the score ...❞

JUNE 21
MAKE MUSIC
WELCOME SUMMER
FÊTE DE LA MUSIQUE
A CELEBRATION OF THE BICENTENNIAL OF THE FRENCH REVOLUTION
PRESENTED BY THE NEW YORK INTERNATIONAL FESTIVAL OF THE ARTS™

THE NEW YORK INTERNATIONAL FESTIVAL OF THE ARTS, INC. DEEPLY APPRECIATES GRANTS WHICH MADE THE FÊTE DE LA MUSIQUE POSSIBLE
CORPORATE SPONSORS: AMERICAN EXPRESS COMPANY, THE CHASE MANHATTAN BANK, THE HEARST CORPORATION, THE MAY DEPARTMENT STORES COMPANY, MORGAN STANLEY GROUP INC., LOUIS VUITTON
FOUNDATION SPONSORS: THE ANDREW W. MELLON FOUNDATION, THE NEW YORK TIMES COMPANY FOUNDATION, HELENA RUBINSTEIN FOUNDATION, SAMUEL AND MAY RUDIN FOUNDATION, INC., THE FAN FOX AND LESLIE R. SAMUELS FOUNDATION

DENTISTS
GL. STRAND COPENHAGEN

LOGO <
1991

MARSELIS MARATHON

POSTER >
70 x 50 CM
1988

" Dentists' signs should show what good teeth can do,
and not get into the opposite at all.
So here, on a sign in the middle of classic Copenhagen,
red as the roof tiles, a patient has high-spiritedly taken
a good bite out of the dentist's street sign!"

MARSELIS LØBET 88

SØNDAG D. 4. SEPT.

HUSK FORTRÆNING HVER MANDAG OG ONSDAG KL. 18.30 I MINDEPARKEN

FÅ TILMELDINGSKUPON I SPORTSFORRETNINGER, PÅ TURISTKONTORET OG
KOMMUNEINFORMATION, ELLER RING PÅ 06 11 07 75.

TEGNET AF PER ARNOLDI

HOTEL SKT. PETRI COPENHAGEN

LOGO ∧
2003

POSTER >
100 x 70 CM
2003

" The Skt. Petri Hotel in the Latin Quarter of Copenhagen, in highly historic university surroundings, is already in itself several layers of history, a refurbishing of the old department store Daells Varehus, an upstandingly *funkis* or functionalist/Deco building from 1932, designed in several stages by the architect Vilhelm Lauritzen.

The funkily optimistic appearance and aura of the building, preserved in the protected outer shell, has all the maritime wave-raking rails and balcony-bulging elements that were such a large part of the carefree vocabulary of the style.

The hotel has taken its name from the neighbourhood and the nearby church Skt. Petri from 1450, the only preserved medieval building in Copenhagen, and its logo from an already built-in, or rather built-out detail of the facade: the droll little balcony, very small and very high up on the tall corner tower.

A really *funkis* signal: Watch out, here I come ...!"

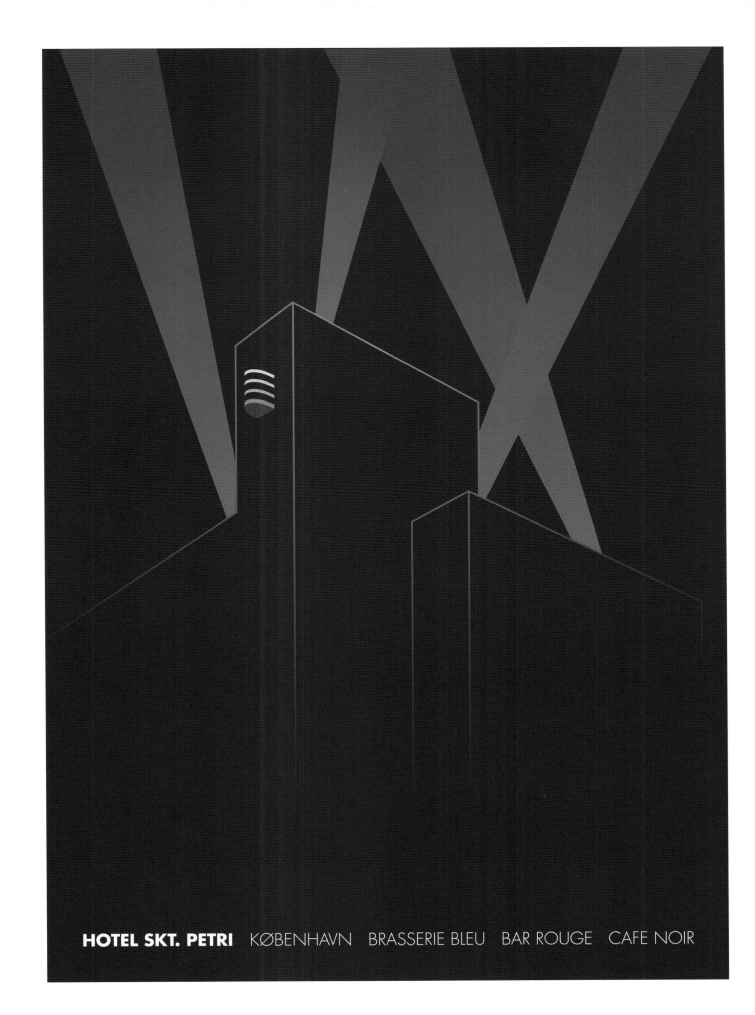

HOTEL SKT. PETRI KØBENHAVN BRASSERIE BLEU BAR ROUGE CAFE NOIR

DENTISTS FAABORG

LOGO ∧
2000

JAZZ CLUB MONTMARTRE COPENHAGEN

POSTER >
170 x 80 CM
1981

" Jazz, opera and dentists ... it's always a challenge when the same subject is to be given yet another image, but for a new client – a symbol which every time has to be as definitive and adequate to the client and genre as possible. The dentists in Faaborg got a white smile on a blue ground. The dentist's smile when the customers come and the customer's smile when he goes".

JAZZ
CLUB MONTMARTRE COPENHAGEN

VEJLE HOSPITAL

LOGO ∧
1991

JAZZ CLUB MONTMARTRE COPENHAGEN

POSTER >
100 x 70 CM
1980

" If you happen to be firmly and permanently convinced that even at its most splintered, Cubism belongs quite naturally with jazz and the combination is here to stay – then what else can you do? The obvious version of yet another jazz poster is the sweet sound of a an offbeat, syncopated, dancing guitar."

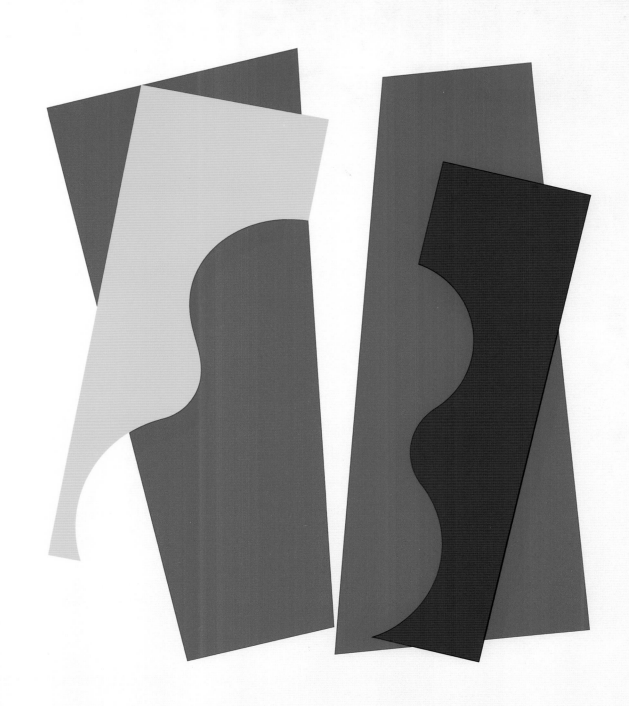

JAZZ
MONTMARTRE COPENHAGEN

DESIGN PER ARNOLDI

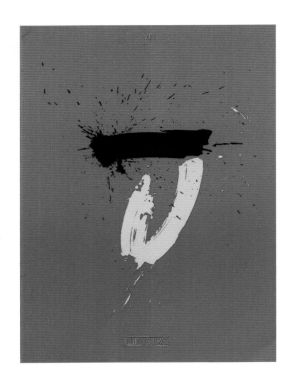

JELLING INN

LOGO <
1994

CALL FOR ENTRIES NEW YORK

POSTER FOR >
NEW YORK ART DIRECTORS' CLUB
60 x 40 CM
1992

" The New York Art Directors' Club's annual
Call for Entries, an invitation to fierce competition among
professional communicators all over the world, has
a built-in reciprocal motion ... you send out to call in. And all
the entries that come in send out signals at full competitive
force ... and that explains the slightly Dick Tracy-like New York
radio-art-wave transmitter ..."

CALL FOR ENTRIES NEW YORK ART DIRECTORS CLUB 7TH INTERNATIONAL EXIBITION DEADLINE 7 DECEMBER 1992

AALBORG THEATRE

LOGO ∧
1994

NOVO RESEARCH

POSTER >
100 x 70 CM
1988

> " As has so truly been said, you shouldn't be afraid
> of the banal ... All graphic communication makes use of
> familiar, recognizable and well-worn symbols!
> So the heart had to be just the ticket again and beat for
> the Aalborg Theatre."

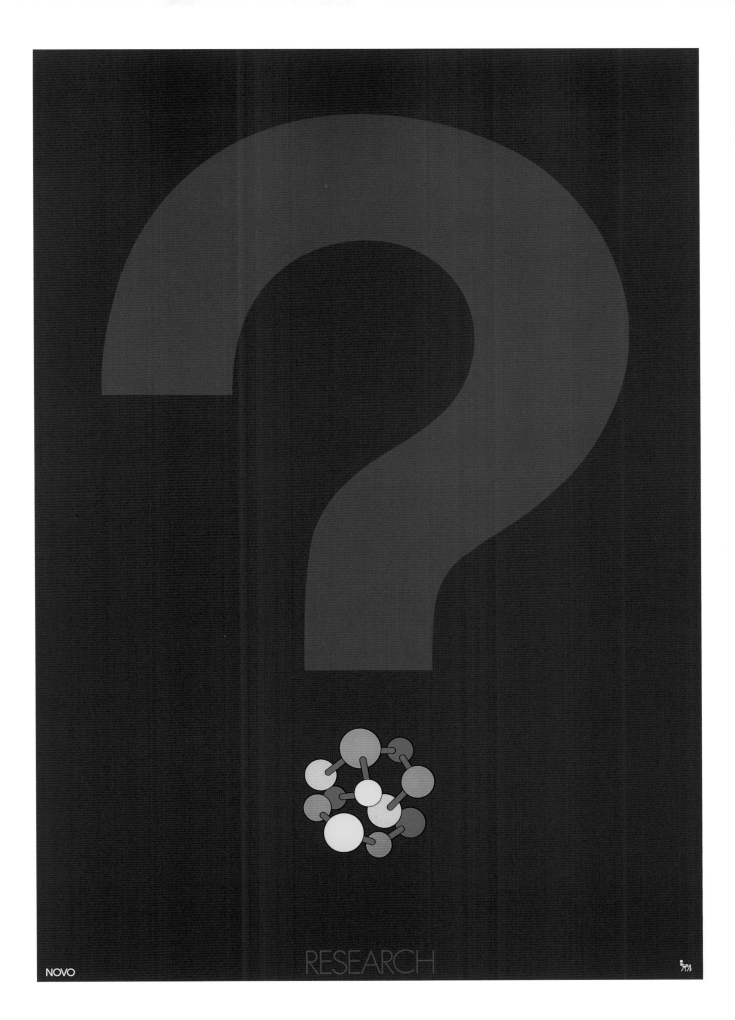

NOVO

RESEARCH

NYKREDIT

LOGO ∧
1986

POSTER >
100 x 70 CM
1986

“ The credit association Nykredit's
new logo, a large geometricized 'N'
spanning and bracing a five-by-five square,
fitted the bill and hopefully created the
necessary trust in the tight structure and
solidity of the credit association ...
So the presentation and implementation
were celebrated with a more loose-limbed
calligraphic version.
The interesting thing about calligraphy is
that you can neither hesitate nor fake it.
And you can only take pains with the
preparations. The process itself takes a split
second. Either the stroke falls right and
that is that and splashes off in the right
direction or that wasn't that and here we
go again.
Both genres – the tightest structure and the
freest brushstroke – have quite inflexible
and invariable rules.”

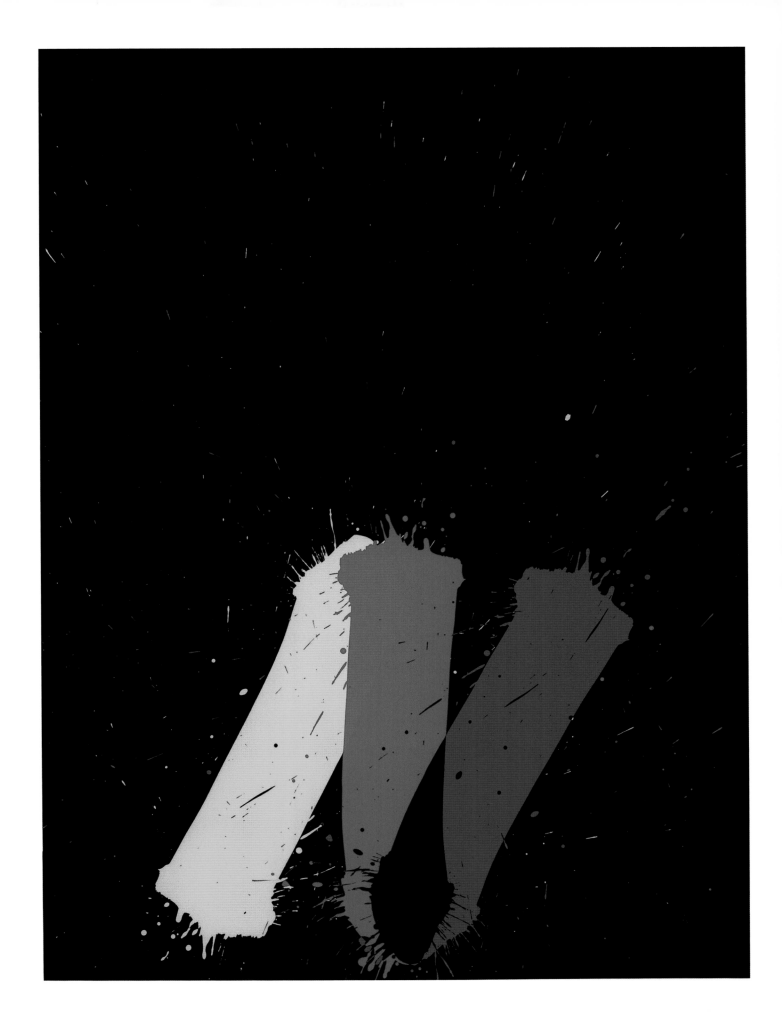

IBRAHIM HUSSEIN CENTRE

LOGO FOR CULTURAL CENTRE MALAYSIA /\
1995

ORDRUPGAARD

POSTER >
142 x 100 CM
1993

" Ordrupgaard is a small sophisticated collection of
French Impressionism and Danish Golden Age art
and some good Hammershøi paintings in a wonderful villa
in the middle of a large park.
Therefore: green!
Given how randomly and often wrongly the hierarchies of
art history have functioned in the past, I tried to see whether
a non-hierarchical, quite simple reeling-off of all the artists
of the collection would whet the appetite more than the
stellar positioning of the accepted masterpieces ... I mean,
who was Antoine-Louis Barye?"

BERTHE MORISOT · CAMILLE PISSARRO · ODILON REDON
THOMAS COUTURE · ARISTIDE MAILLOL · CLAUDE MONET
AUGUSTE RODIN · THÉODORE ROUSSEAU · CARL MILLES
LOUIS ANQUETIN · MICHAEL ANCHER · JENS SØRENSEN
ALFRED SISLEY · ALBERT MARQUET · SIEGFRID WAGNER
JACOB E. BANG · JENS BIRKEMOSE · C. W. ECKERSBERG
FRANCOIS-ÉMILE DÉCORCHEMENT · JULIUS PAULSEN
ARMAND GUILLAUMIN · CARL HOLSØE · JAIS NIELSEN
PAUL GAUGUIN · EFFIE HEGERMANN-LINDENCRONE
AUGUSTE RODIN · SUSETTE HOLTEN · VIGGO JOHANSEN
ALBERT ANDRÉ · ÉDOUARD MANET · KAREN HANNOVER
CHRISTEN KØBKE · KARL DAUBIGNY · EVA SØRENSEN
NARCISSE DIAZ DE LA PENA · WILHELM MARSTRAND
L. A. RING · JOAKIM SKOVGAARD · J. P. DAHL-JENSEN
FRITZ SYBERG · EVA GONZALÈZ · ADOLPHE MONTICELLI
VILHELM HAMMERSHØI · JEAN-FRANCOIS RAFFAËLLI
THEODOR PHILIPSEN · CONSTANT TROYON · L. A. RING
SIMON GATE · EDWARD HALD · MAURICE DE VLAMINCK
THEODORE GÉRICAULT · JULES DUPRÉ · JØRGEN ROED
P. C. SKOVGAARD · NIELS SKOVGAARD · HANS SMIDTH
EMILE LENOBLE · JOHANNES LARSEN · HENRI MATISSE
HENRI-ÉDOUARD NAVARRE · THORVALD BINDESBØLL
KRISTIAN ZAHRTMANN · CLAUDE MONET · J. TH. LUNDBYE
CHARLES DESPIAU · JEAN GAUGUIN · CHRISTEN KØBKE
C. A. JENSEN · LUDVIG BRANDSTRUP · ÉDOUARD MANET
ANTOINE-LOUIS BARYE · PETER HANSEN · EDGAR DEGAS
KAI NIELSEN · SVEND HAMMERSHØI · EUGÈNE BOUDIN
PAUL CÉZANNE · CAMILLE COROT · GUSTAVE COURBET
CONSTANTIN HANSEN · CHARLES-FRANCOIS DAUBIGNY
BODE WILLUMSEN · EDGAR DEGAS · EUGÈNE DELACROIX
ALFRED SISLEY · HONORÉ DAUMIER · CONSTANTIN GUYS
VILHELM KYHN · JEAN-AUGUSTE-DOMINIQUE INGRES
PAUL GAUGUIN · NIELS NIELSEN · AUGUSTE RENOIR...

1918 ORDRUPGAARD 1993

MALERI · SKULPTUR · KUNSTHÅNDVÆRK · PARK · CAFE · VILVORDEVEJ 110
CHARLOTTENLUND

GLOBAL BIODIVERSITY

LOGO FOR GLOBAL BIODIVERSITY ∧
INFORMATION FACILITY •
2002

FREDERICIA BREWERY

POSTER >
100 x 70 CM
1993

" The Fredericia Brewery was to inaugurate
a new bottling hall where I had done a large-scale colour
scheme and sculptural decoration.
How lucky can you get? The hall had the number four,
and the figure four, on the invitation and poster,
could very accurately reproduce the exact formal idiom
I had topped up the hall with.
Big brightly coloured beams across all the boundaries of
functional sense and sensibility, up and down and athwart
and straight through everything, blustered cheerfully
through the lovely clink and clatter of the hall ..."

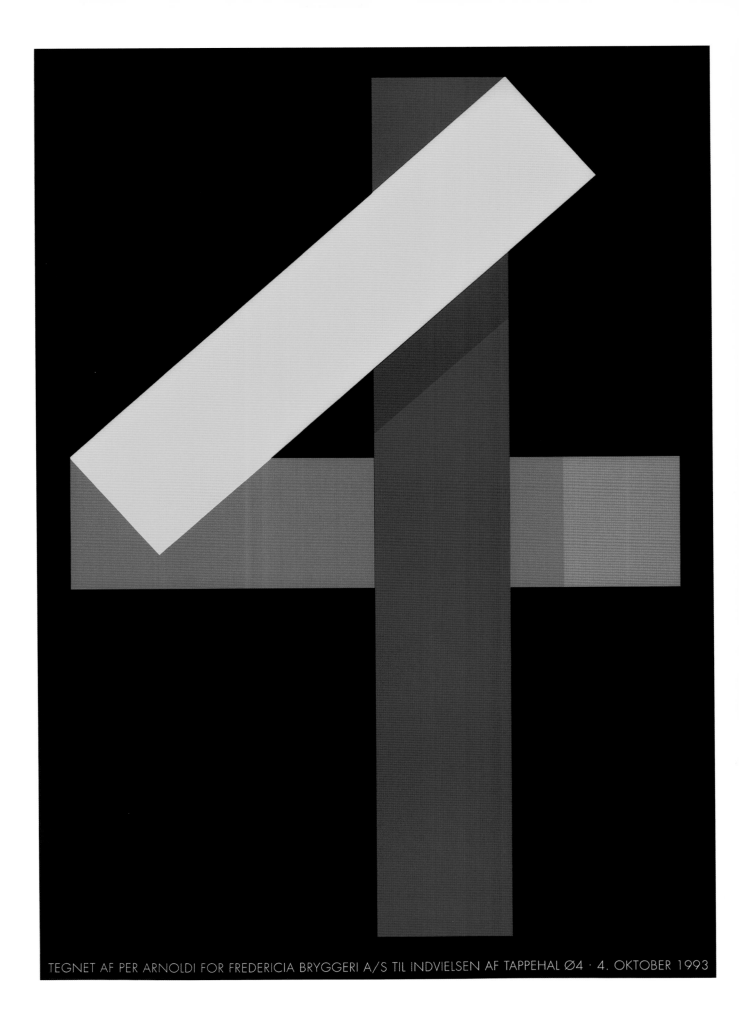

TEGNET AF PER ARNOLDI FOR FREDERICIA BRYGGERI A/S TIL INDVIELSEN AF TAPPEHAL Ø4 · 4. OKTOBER 1993

THE ELVERDAM INN

LOGO ∧

1997

**ØSTRE GASVÆRK THEATRE
COPENHAGEN**

POSTER >

120 x 70 CM

1984

“ For the opening of the theatre in
Nyrop's fantastic disused gasometer
in Østerbro, Copenhagen, I just couldn't
get round the building. It's big!
I put the over-perspectivized stage boards
outside, or put the building up in the
middle of the stage, you could say, and then
did the lighting – from the inside.
I lit up the little necklace of round windows,
which change shape with the form of the
building, in a sequence from yellow to red
to exaggerate, dramatize and accentuate
the shape. But I wasn't prepared for the
glowing sea of light that the course of the
window from circle to ellipse would create …
and in a flaming gasometer too!

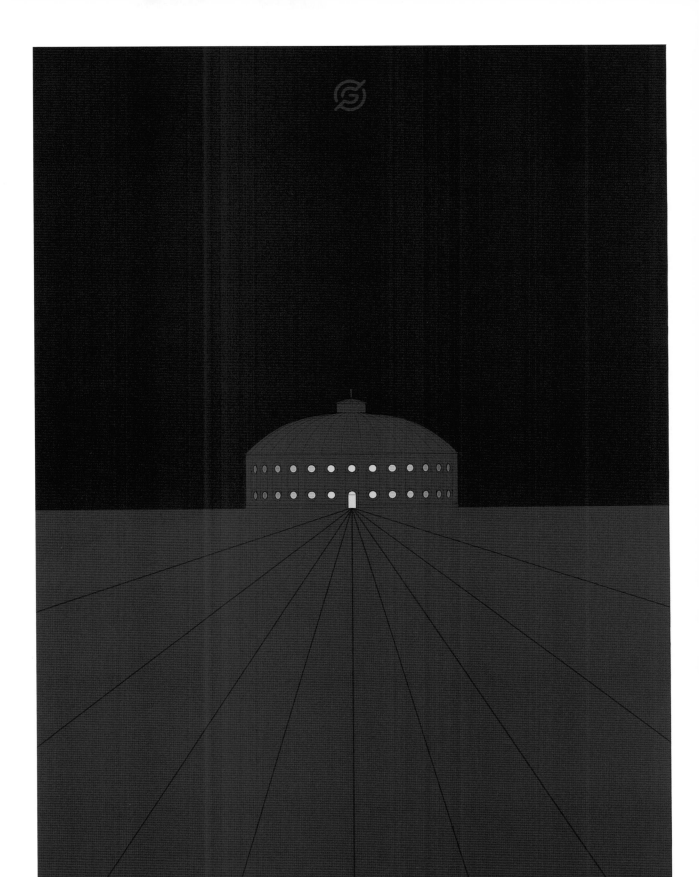

ØSTRE GASVÆRK TEATER
COPENHAGEN

PARALYMPICS

SKETCH ∧
1996

POSTER >
70 x 50 CM
1996

" The Paralympics are the Olympics for the disabled. In this case a handicap isn't a set of rules to even things out, but certain conditions that the participants share ... in all variations.

I chose to make a paraphrase of the Olympic logo, the same symbol of solidarity etc. ... but more movingly, among participants of all kinds, to put it mildly!

The interesting thing was that this simple graphic variation seemed to show the unbearably uniform perfectionistic Olympic rings in a new light ... That actually wasn't the nature of the task ... but I know which one will win here – if that's what it's about at all ..."

READ POLITIKEN

POSTERS ∧ >

120 x 80 CM

1979

> " Ib Andersen's logotype for POLITIKEN is, like the newspaper itself, a striking element in the everyday life of the city. The eye recognizes the fragments, the sections, from up and down and far away, with no difficulty. The campaign for Politiken, which filled all stations in four colour variations, mirrored the paper's logo in the glasses.
>
> One of the editors asked me if I was claiming that the average age of the readership was up in the bifocal bracket. Well, what I needed most was the image that followed the word 'read', and which could be a mirror image, so we could play on the already established newspaper name. It couldn't have been done with a new product.
>
> Politiken has had a great tradition for covering art, architecture and design material since the thirties, which must be where the granny glasses come from – that is, unless they're actually Mondrian's spectacles attentively observing the images of the age ..."

LÆS

PER ARNOLDI 200 AFFISCHER
KULTURHUSET STOCKHOLM 8 DEC. 2001 · 20 JAN. 2002

WORLD'S FAIR SEVILLE

LOGO >
1992

POSTERS >
100 x 70 CM
1992

"The Danish pavilion at the World's Fair in Seville in 1992 was spectacular. But then so many of the other countries' pavilions were too, so the impact of our participation depended a lot on the content of the pavilion, and on my part of the job, the story about Denmark – the "Vision Denmark" – which would hopefully spread like ripples in the water with the pavilion as the centre. The job was defined as a series of posters, which would spread the good news in eight 'glimpses'.

I ordered the posters in pairs, each one with a quite simple icon and a little story printed on it ... a little more wordy than posters usually are. But in the nature of things the material was very extensive. The first two motifs defined the 'sender' of the message – a poster with a model photo of the architect Jan Søndergaard's pavilion, and one with my own logo for our efforts and ambitions: Vision Denmark, the pavilion, a sail and logo, the eye of the prow optimistically on the future ... no national nostalgia yet. Then two posters about the country: the flag, also in a table model version with its own legend about falling from heaven, and a poster about the national bird, the swan, as an egg and feather, so as to get Hans Christian Andersen's little ugly duckling in from the start.

A couple of posters about our well-balanced mixture of functioning democracy and sparkling monarchy, the story told with Johan Rohde's formally perfect speaker's bell from the Danish Parliament, made by the Georg Jensen silversmiths, and the Orb of the Crown Jewels in Rosenborg Castle, photographed amidst a huge security fuss one early morning when we could switch off all the alarms for the space of a flash. And finally, culture and nature: a tightly structured sculpture by Robert Jacobsen, and nature gathered in a matchless wild bouquet by Erik Bering.

The whole series was staged in a cool grey room on radiant ultramarine pedestals ... the national colour, if I were to choose one, which in fact is what I did!

The Seville Fair has long been over and the pavilion has been taken down and sold – out of all context – to Japan.

The many posters live on.

Transient arts can be tenacious."

241

PER ARNOLDI HAR TEGNET LOGO
TIL VISION DANMARK.

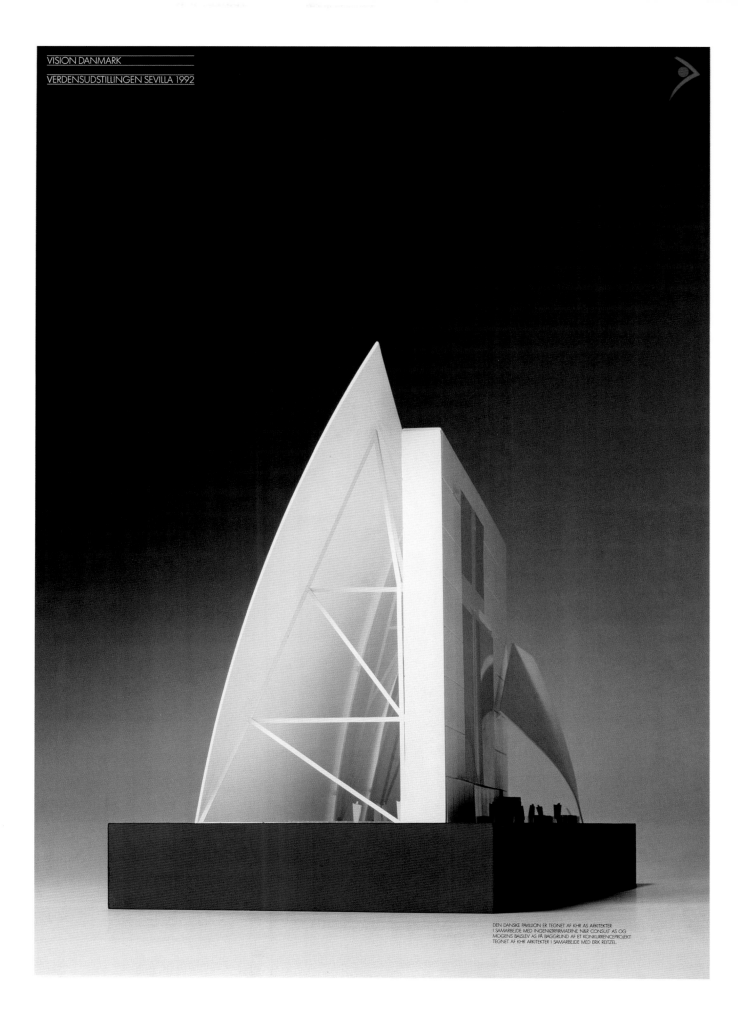

DEN DANSKE PAVILLON ER TEGNET AF KHR AS ARKITEKTER
I SAMARBEJDE MED INGENIØRFIRMAERNE N&R CONSULT AS OG
MOGENS BALSLEV AS PÅ BAGGRUND AF ET KONKURRENCEPROJEKT
TEGNET AF KHR ARKITEKTER I SAMARBEJDE MED ERIK REITZEL.

DANNEBROG FALDT IFØLGE TRADITIONEN
NED FRA HIMLEN UNDER VALDEMAR II SEJRS
TOGT TIL ESTLAND 1219.

H. C. ANDERSEN SKREV EVENTYRET OM
DEN GRIMME ÆLLING I 1842.

JOHAN ROHDE TEGNEDE I 1927 FOLKETINGETS
DIRIGENTKLOKKE I SØLV OG IBENHOLT FOR
GEORG JENSENS SØLVSMEDIE

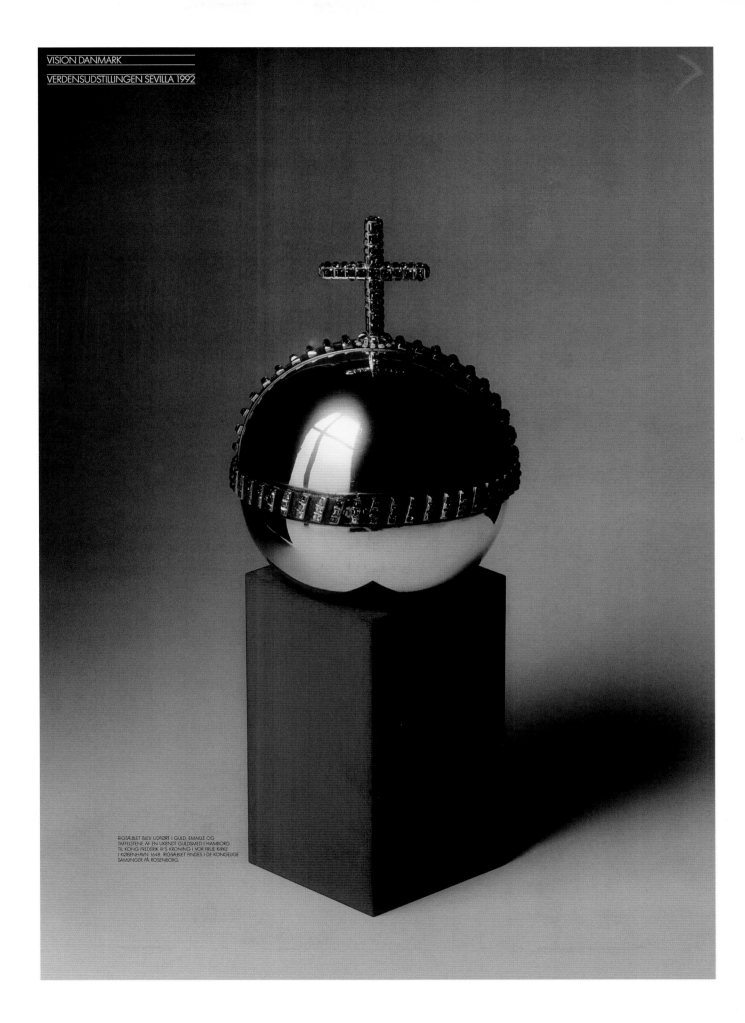

RIGSÆBLET BLEV UDFØRT I GULD, EMAILLE OG
TAFFELSTENE AF EN UKENDT GULDSMED I HAMBORG
TIL KONG FREDERIK III'S KRONING I VOR FRUE KIRKE
I KØBENHAVN 1648. RIGSÆBLET FINDES I DE KONGELIGE
SAMLINGER PÅ ROSENBORG.

ROBERT JACOBSEN SKABTE JERNSKULPTUREN
ESPACE UNIVERSEL 1981.

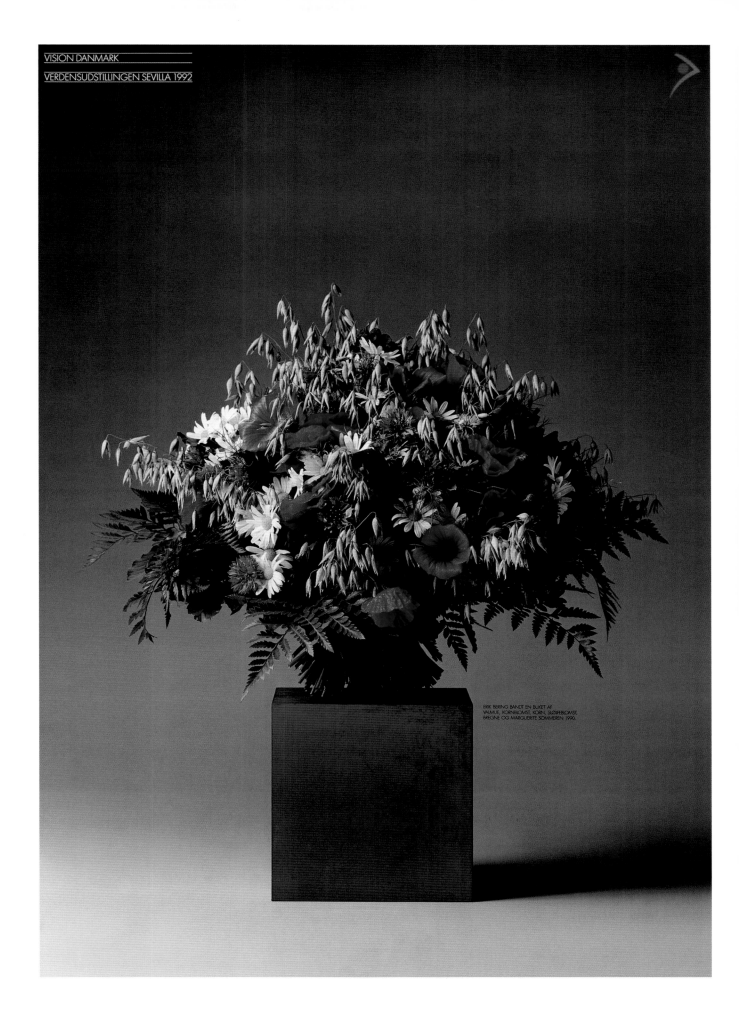

ERIK BERING BANDT EN BUKET AF
VALMUE, KORNBLOMST, KORN, SLØJFEBLOMST,
BREGNE OG MARGUERITE SOMMEREN 1990.

SKETCH

2003 ∧

4TH MAY 1945
LIBERATION OF DENMARK

POSTER >
100 x 70 CM
1995

❝ A fiftieth anniversary poster with liberating graffiti (the background is the famous infamous flier that announced the German Occupation to the dumbfounded Danes on 9th April 1940).❞

OPROP!

Til Danmarks Sol[...] [...]anmarks Folk!

Uten Grund og imot den tysk[...] [...] oprigtige Ønske, om at leve i Fred og Venskab med det engelske og d[...] [...]ts Magtehavere ifjor i September erklæret Tyskland Krigen.

Deres Hensigt var o[...] [...]rigsskuepladser som ligger mere afsides og derfor er m[...] [...]ab, at det ikke ville være mulig for Tyskland, at ku[...]

Af denne G[...] [...]s og Norges Noitralitæt og deres territoriale Far[...]

Det [...] [...]n yderlig Anledning ikke synes at være g[...] [...] erklæret og truet, ikke mere at taale den [...] [...]or d[...] [...]d ved Nordsjøen og i de norske Farvand. Man er[...] [...]a Politi[...] [...] tilslut truffet alle Forberedelser for overraskende [...] alle nod[...] [...] ved Norges Kyst. Aarhunredes storste Krigsdriver, [...] [...]en forste Ver[...] [...]hele Menneskeheden arbeidende Churchill, uttalte [...] at han ikke var [...] [...]olde tilbake af »legale Afgjørelser eller nøitrale Rettighe[...] [...]staar paa Papirlapper[...]

Han har forber[...] [...]laget mot den [...] [...]n Dager siden er han blit utnævnt til for[...] [...]lig [...]

Den tyske Regjering [...] [...] den kan ikke taale, at en ny Kriksskueplads nur [...]

Den danske og den norske Re[...] [...] Forsøk.

Likeledes er deres [...] [...] er hverken villige eller istand til at kunne yd[...]

Derfor har Tyskl[...] [...] Magtmidler selv at overta Beskyttelsen av Dan[...] os og Norges Kong[...] [...]rne den saalænge Krigen varer.

Det er ikke den tyske Regjerings Hensigt [...] [...]punkt i Kampen mot England, den har udelukkende det Maal at forhindre at S[...] [...]ark for de engelske Krigsudvidelser.

Af denne Grund har stærke tyske Milit[...] [...]orges tat Besiddelse af de vigtigste militære Objekter i Danmark og Norge. Over [...] [...]effes der for Tiden Overenskomster mellem den tyske Riksregjering og den Kong[...] [...]. Disse Overenskomster skal sikre at Kongeriget bestaar videre, at Hæren og Flaa[...] [...]Danske Folks Frihet agtes og at dette Lands fremtidige Uafhængighed fuldt ut [...]

Indtil disse Forhandlinger er afsluttet, m[...] [...]og Flaaten har Forstaaelse for dette, likeledes at Folket og alle kommunale Seder [...] [...]d Vilje, slik at de undlater enhver passiv eller aktiv Motstand. Den vilde være [...] [...] med alle Magtmidler. Alle militære og kommunale Steder anmodes derfor straks [...] [...]d de tyske Kommandører.

Folket opfordres til at fortsætte det d[...] [...]orge for Rolighed og Orden!

For Landets Sikkerhet mod engelske [...] [...]af den tyske Hær og Flaade.

D[...] Tyske Kommandør

Kaupisch

4. MAJ 1995 RÅDHUSPLADSEN KL. 20.36

Arrangør: 4. MAJ Komiteen (LO København, LO Storkøbenhavn, Faglninger mod racisme, Arbejderbevægelsens Internationale Forum København/Frederiksberg, Byggefagenes Samvirke, Aktive Modstandsfolk, 4. maj initiativet på Vesterbro, Demos og Kunstnere for Fred)

ARNOLD ©

RESTAURANT PIERRE GAGNAIRE PARIS

LOGO <
1990

POSTER >
120 × 80 CM
1988

" I met Pierre Gagnaire because I had heard that in his (then) one-star restaurant in St. Etienne he had my Dizzy Gillespie poster hanging, playing modern jazz to accompany the food, and also that he was a culinary genius! A good enough excuse to visit his kitchen and himself, and a great experience and an agreement to do a poster for the restaurant. It's important to remember that the dominant tradition for the graphic signals of top French restaurants is normally anything but the lean-lined Mondrianesque table I suggested ... But Pierre Gagnaire's cuisine was also anything but French mainstream tradition and was in full fantastical flight forward to the three stars he soon got and took to Paris, where my ascetic table is now the logo and is everywhere in his incredible universe."

PIERRE GAGNAIRE RESTAURANT

LOGO

2004 ∧

RATIONEL VINDUER A/S

POSTER >
100 x 70 CM
1980

❝ Windows from Rationel Vinduer are rational and solid and sensible and sealed and their angles are as right as rain and the colours have to do the rest!"

rationel vinduer a/s

Poster design Arnold. Printed in Denmark by Kai Svendsen

WILHELM HANSEN FOUNDATION

LOGO ∧
1994

POST OFFICE NEW PRICES

POSTER >
100 x 70 CM
2003

" In January 2003 the Post Office introduced new rates where not only the weight of the letters but also their size determined the postage. A lot of good energy was devoted to explaining the new, slightly complicated arrangements, including a poster that sent all the letters in all sizes and colours speeding hopefully towards a safe arrival. And on top of this, there were three million small folders with the same optimistic motif ... So the motif at least has reached all corners of the country ..."

NYE PRISER 2.JANUAR 2003
FÅ PRISFOLDEREN HER

RANDERS CITY ORCHESTRA

LOGO /\
1991

POSTER >
100 x 70 CM
1991

" All symphonic euphony begins, presumably, with one note: the concert-pitch A of the tuning fork.
So this was the image of the great, ambitious orchestral sound concentrated in a single symbol!
A pedantic physics teacher in Randers complained to the orchestra about its new logo, because – as is no doubt physically correct – a tuning fork doesn't vibrate that way!
Well, as long as the orchestra has good vibes ...!"

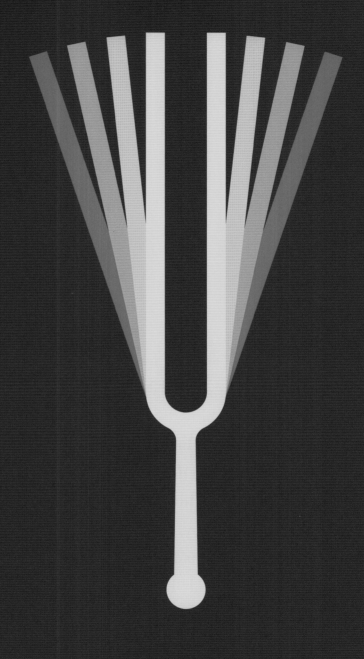

RANDERS BYORKESTER

YONADAB

LOGO FOR YONADAB THE WATCHER ∧
BY PETER SHAFFER LONDON •
1985

ENVIRONMENT AND DEVELOPMENT

POSTER >
70 x 50 CM
1992

" The ambitious, optimistic environmental conference of
the United Nations in Rio was given extra voice and
visibility by a number of invited poster artists' renderings of bits
of the big picture that was the concern of the conference.
Where does one begin, and how is it all to end?
The white cloud had served me well many times as a little
chubby, gentle symbol, for all's well when the weather is with us!
So it had to take the air yet again, but in a dramatized, burst,
non-idyllic version – undaunted but endangered."

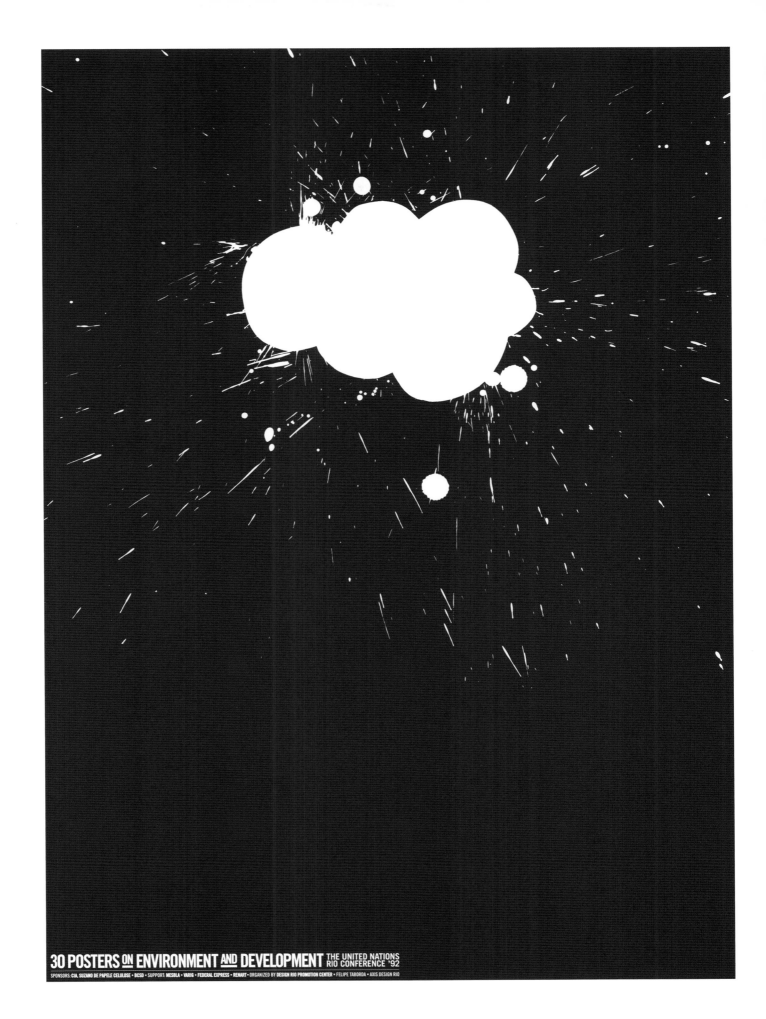

30 POSTERS ON ENVIRONMENT AND DEVELOPMENT THE UNITED NATIONS RIO CONFERENCE '92

SPONSORS: CIA. SUZANO DE PAPELE CELULOSE • BCSD • SUPPORT: MESBLA • VARIG • FEDERAL EXPRESS • RENART • ORGANIZED BY DESIGN RIO PROMOTION CENTER • FELIPE TABORDA • AXIS DESIGN RIO

SKETCH

2001 ∧

**NATIONAL ASSOCIATION OF
FAMILIES OF THE MENTALLY ILL**

POSTER >
100 x 70 CM
1994

 Mental disorders are to a great extent also disorders for the families.

I thought that the confusions and delusions of the crumpled mind could be symbolized by the crumpled paper ... irrevocably torn apart, perhaps not quite hopelessly crumpled to the unrecognizable and unrecognizing that is so unbearable for both patient and family. Perhaps there's some hope that the mind can be smoothed out again! It turned out that my picture was interpreted much more by the families, very strongly and very personally, as a mental image, if the expression can be used here, of *their* endless worries."

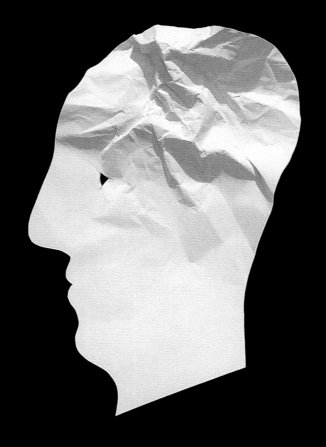

Landsforeningen
PÅRØRENDE TIL SINDSLIDENDE
Nørre Søpark, Ryesgade 17, 2200 København N. Tlf. 35 37 30 45

HORESTA

HOTEL QUALIFICATION SIGN DENMARK ∧
1997

SOS CHILDREN´S VILLAGES

POSTER >
100 x 70 CM
1998

" An SOS has to be very direct, as clear as possible and as easily decipherable as possible.

Well, if this SOS had been sent out by children and those children had written it with their brightest crayons and the same crayons had been crushed by some terrible impact, this SOS could not be repeated and sent out again ...

This first trembling cry for help must be answered immediately, for the disaster *has* already happened.

It's that simple, unfortunately."

BØRNEBYERNE

DANISH MARITIME AUTHORITY

LOGO • ∧
1983

SEAMANSHIP TRAINING

POSTER >
100 x 70 CM
1992

" Often I've been successful in drawing the horizon down into a poster. Venice on the horizon, the escape over the water in October 1943 and then here, like a little game, the far horizon, seamanship training's lure of the long voyage pulled right down into the far-seeing, forward-looking magical lenses of the binoculars ... so blue, so close, so far, so good."

FREMTIDSUDSIGTER

FÅ EN SØFARTSUDDANNELSE

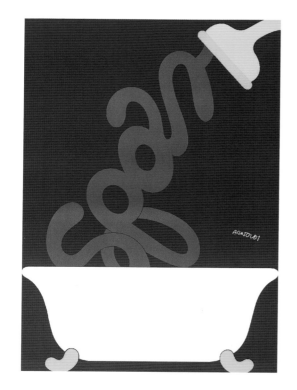

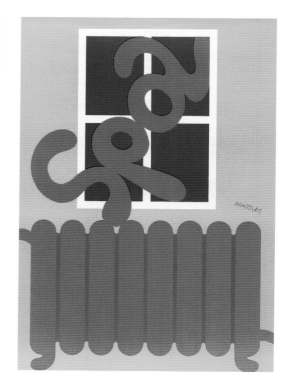

SAVE ENERGY

POSTERS FOR MINISTRY OF ENERGY ∧ >
100 x 70 CM
1978

> " Posters are designed, produced, are used and disappear.
> There's something wonderfully everyday, robust and unpretentious about a big campaign's quick, uninhibited use of a large brightly-coloured printing.
> For the Ministry of Energy I designed a series of four posters where the word 'spar' (save) was part of the picture.
> Save petrol, save electricity, save heat and save hot water.
> We printed 100,000 posters, which were pasted up, sent out, sold and chucked at people, given to schools and forced on public offices and were gone. I have *one* set myself."

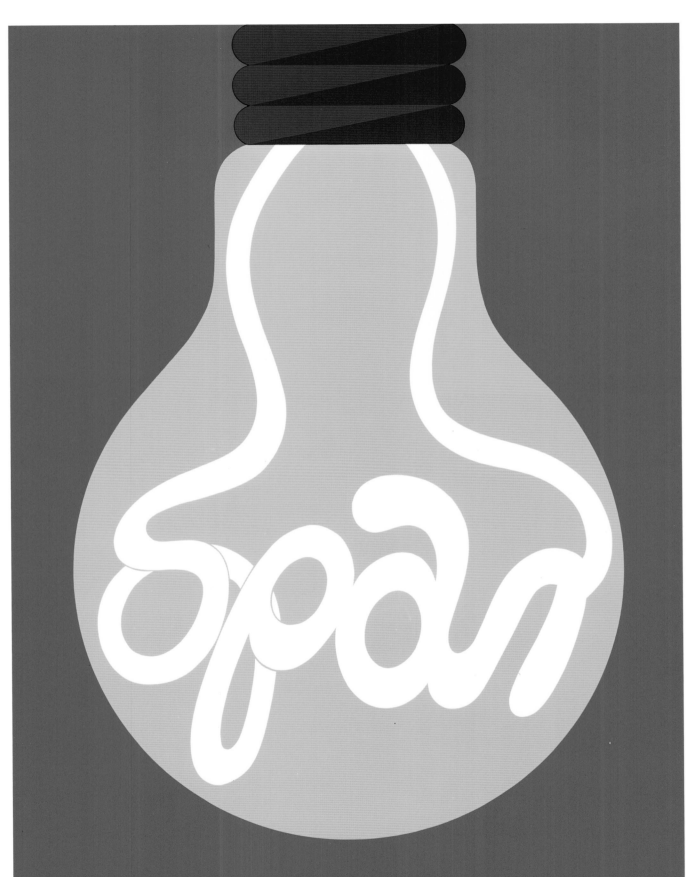

VILHELM ZELTNER

LOGO FOR BUILDING FIRM <

1980

TIVOLI

POSTER >

85 x 60 CM

1999

" The pleasure of anticipation is the
first pleasure – and often perhaps
endures longer than what you were
looking forward to so much.
I can still remember the hour before a
concert with the Count Basie Orchestra on
the open-air stage Plænen in Tivoli
Gardens many years ago.
The whole set-up was ready. The chairs,
the instruments and a white summer
sail pitched and stretched across the stage.
All that was missing was the band and Basie ...
but the waiting period and the 'still life'
of the orchestra or at least the orchestra's
equipment were pure, joyous magic.
Many years later when I was to draw my
poster into the series of Tivoli posters, for
a garden that feeds on its thousand
images, this fragment of memory was still
the most wonderful thing about it ..."

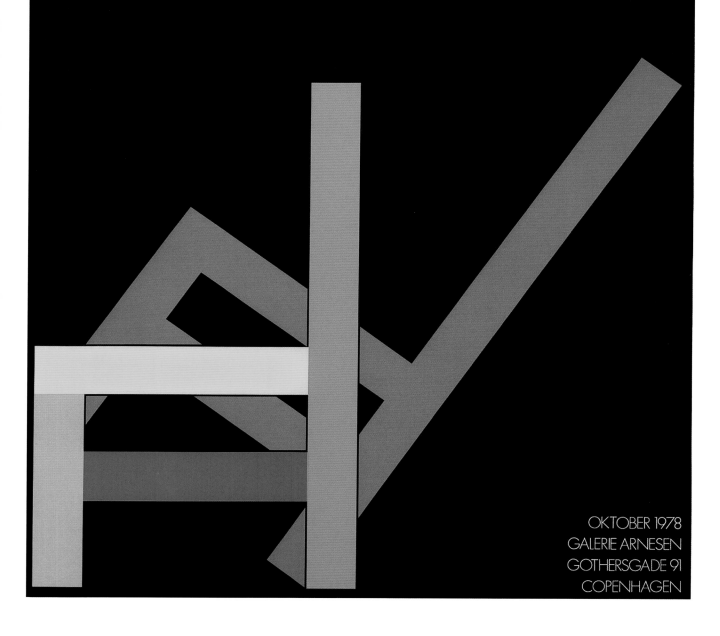

ARNOLDI

OKTOBER 1978
GALERIE ARNESEN
GOTHERSGADE 91
COPENHAGEN

LOGO >

1996

HELSINGØR / HELSINGBORG

POSTER >

120 x 80 CM

1996

" Helsingør and Helsingborg face each other, one on each side of the Sound between Denmark and Sweden, and Danish Rail's ferries, which sail boldly back and forth, were to compete with private ferry companies for the short crossing on both sides. I couldn't resist the obvious possibility this presented for printing the same poster upside down, so to speak, and then just turning it the right way round in the relevant right-way-round city on the other side ..."

HELSINGØR

DSB

OVERFARTEN MED DE FLESTE AFGANGE

HELSINGBORG

DSB

OVERFARTEN MED DE FLESTE AFGANGE

HELSINGBORG

DSB

OVERFARTEN MED DE FLESTE AFGANGE

HELSINGØR

DSB

OVERFARTEN MED DE FLESTE AFGANGE

DIE SPITZE DER PYRAMIDE GERMANY

POSTER <
70 x 50 CM
1982

TORTURE

POSTER >
100 x 70 CM
1998

" In 1982 the German magazine
Der Spiegel commissioned a
de luxe poster as a gift and as bait for its
advertisers.
The title was given in advance – "The
Peaks of the Pyramids". Every year a new
artist has to struggle with the design of
this unstintingly flattering and shamelessly
promising tale and assurance that both
sender and receiver are undoubtedly
already on top of the world, pyramidally
unbudgeable; but also that continued close
collaboration will ensure this position for
all time.
I was next after Max Bill, who had cast a
spell with the razor-sharp geometry of the
pyramid, and chose what was perhaps a
rather Danish, moderate version. It could
be that a few steps had to be taken
before you reached the golden summit!"

26. JUNI FN'S INTERNATIONALE MÆRKEDAG TIL STØTTE FOR TORTUROFRE OG BEKÆMPELSE AF TORTUR

DENNE PLAKAT ER FREMSTILLET FOR REHABILITERINGS- OG FORSKNINGSCENTRET FOR TORTUROFRE (RCT) OG INTERNATIONAL REHABILITATION COUNCIL FOR TORTURE VICTIMS (IRCT)

ONE

LOGO

2004 ∧

VENICE

POSTER >
90 x 75 CM
1975

" It doesn't take much to evoke the pictures or the swarm of images from memory when Venice looms on the horizon in the poster. The name is enough! Out there in the water lies the enchanted city, against all odds and defying all physical realities, and from afar off it radiates the indomitable, stubborn, shameless pride that once made the Republic a world power – a rare power that knew and demonstrated that without art there is no magic!"

VENEZIA

NEW YORK

LOGO • ∧
1979

VENICE IN PERIL

POSTER • >
100 x 70 CM
2002

" Venice is sinking!
The question mark means does it have be that way?"

VENEZIA?

KØGE RIDING SPORTS CLUB

LOGO /\
2003

ZOOT SIMS

POSTER • >
100 x 70 CM
2003

" You can also take the initiative for
a poster yourself. I mean, I couldn't
be sure that the wonderful American
tenor saxophonist Zoot Sims would travel
round the world and play and would want
a Danish-designed poster; but I'd always
been very fond of his music and of his
highly graphic name: Zoot.
I had pursued him a couple of times and
pestered him with the offer of my services
without anything more coming out of it
than a few tumultuous and marvellous jazz
evenings out of that horn.
So nothing came of it until this draft,
which is now more in memory of Zoot and
a great evening in that quintessence of
Copenhagen, the wild jazz pub Vingaarden!"

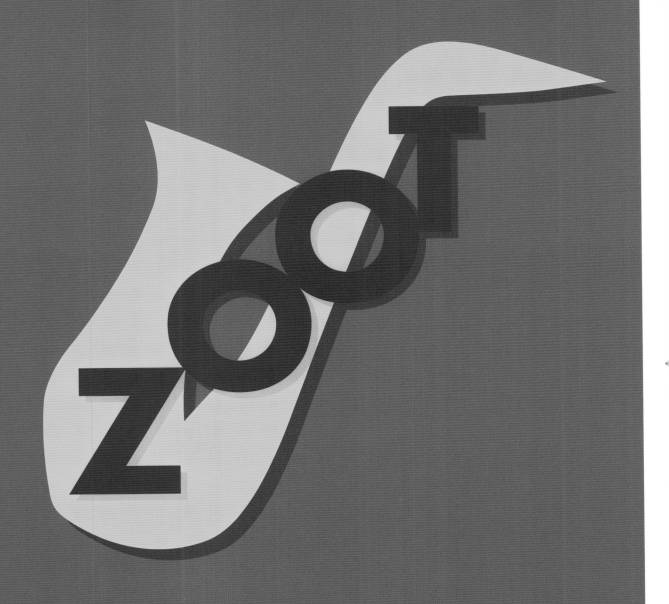

ZOOT SIMS VINGAARDEN KØBENHAVN

YEAR OF THE BRAIN

LOGO ∧
1997

WORLD STROKE DAY

POSTER FOR >
THE NATIONAL STROKE ASSOCIATION
100 x 70 CM
2001

"It's in the nature of the poster to exaggerate. My draft for the poster for the conferences and other initiatives on the Stroke Day was so wildly exaggerated and dramatic that it was at first rejected. No patient would survive such a severe cerebral haemorrhage, and all the positive measures of the conferences would have been superfluous. The argument was true enough ... but if you must have a poster it has to live its life in accordance with the conditions and ground rules of the poster. Naturalism? A correct X-ray from a real case would in the first place only be about that particular case; and secondly it wouldn't embrace the whole topic as dramatically and effectively as precisely this kind of exaggeration naturally does. That's what the poster can do ... eliminate naturalism, draw attention to the phenomenon or rather the many variations on the phenomenon, and present the problem, not the solution, for the large non-scientific forum.
Agit-art!"

VERDENS **APOPLEKSI**DAGEN **10 MAJ** 2001

THE CAPTAIN FROM KÖPENICK

POSTER FOR GLADSAXE THEATRE <

COPENHAGEN

50 x 35 CM

1971

WORLD WILDLIFE FUND

POSTER >

100 x 70 CM

1993

"The world's wildlife is threatened. The World Wildlife Fund tries to do something about it!

But when you're free to choose a poster motif for the Fund, there are still plenty of species to choose from.

I chose the whale, partly because it gave me yet another chance to print a large blue surface, partly because the tail, so overwhelming and moving, becomes a concentrated image of the huge animal we never see, which disappears into the sea and may perhaps disappear in reality ...

The poster was to be sold to raise money for the continued work of the Fund, and it was a huge financial success. It turned out that I had made the right choice without anyone from the Fund telling me what was apparently their good old golden rule of thumb: always choose a very large or a very small animal if you want to appeal to as many people as possible. The elephant or the whale or the dormouse or the wren ...

And I thought they were all buying my blue!"

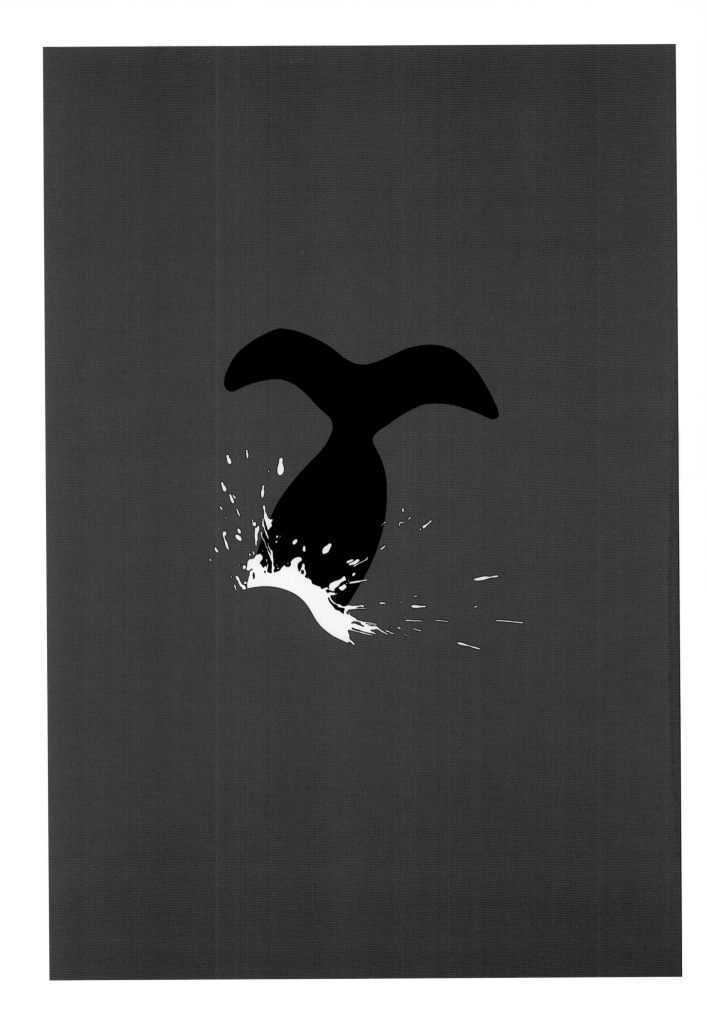

WORLD BOOK DAY

LOGO ∧
2002

POSTER >
80 x 60 CM
2002

" It may well be that amazing amounts of information are flying around in cyberspace, gathered in some infinity, however that can be ... Incredible and fantastic and quite understandably fascinating.
But just as fantastic and fascinating are the long, tough, stubborn life and impact and spread of the book, and that is what World Book Day celebrates."

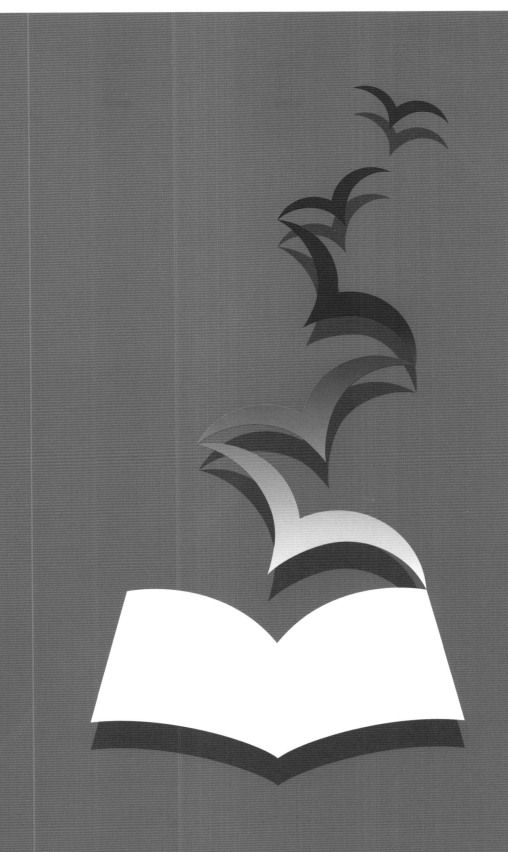

VERDENS BOGDAG 23 APRIL 2002

STRING SWING RED SHOES

POSTER <

100 x 70 CM

2001

MONTREUX JAZZ FESTIVAL

POSTER >

100 x 70 CM

1994

"The Montreux Jazz Festival cuts loose every summer in Montreux on the calm, idyllically trimmed shores of Lake Geneva and shatters the massive Swiss quiet.

Every summer ... just like another summer phenomenon that, funnily enough, also rears its head from another mountain lake, when the tourist season in Scotland needs a boost from the amenable animal at the bottom of Loch Ness!

So I couldn't resist the parallels: there in the Highlands, the discreet but punctual monster; and here in Montreux

– *monstreux!* – the Loch Jazz Monster, the snaky body and low grumble and howl and scream and noise and hullabaloo of the sax as long as it lasts and then back again next year."

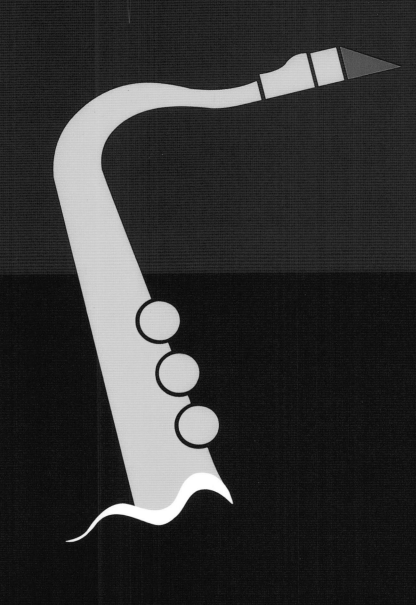

MONTREUX 28TH **JAZZ FESTIVAL**

JULY 1-16

1994

**WILHELM HANSEN
MUSIC PUBLISHERS**

VIGNETTE <

1988

MAY 1945 40 YEARS

POSTER FOR THE MUSEUM >

OF DANISH RESISTANCE COPENHAGEN

100 x 70 CM

1985

"On the evening of 4th May, for the first time in five years in 1945, and then every year since, the Danes have lit candles in their windows to celebrate their Liberation from five years of German Occupation.

The Museum of Danish Resistance in Copenhagen asked me to design a poster for the celebrations of the fortieth anniversary of the Liberation in May 1985.

The Occupation period has a great tradition of graphic signals, because the message then – what the secret press had to express – was so important.

The content determined the form – not the fonts, the paper type, or the number of colours available.

The poster had to live up to this tradition – it had to include a clear symbol of freedom and to recall the regime that had oppressed the country for the previous five years.

I hope the image I chose also contains, besides these elements, a *Lehrstück* or lesson that justifies this wordy text for a picture that was meant to manage without an accompanying lecture.

The dove that flies in the dark war sky is caught in the sweeping, perilous searchlights. The planes have become peace.

Down in the darkness the lights in the blacked-out city go on, to form the letters 5th May 1945."

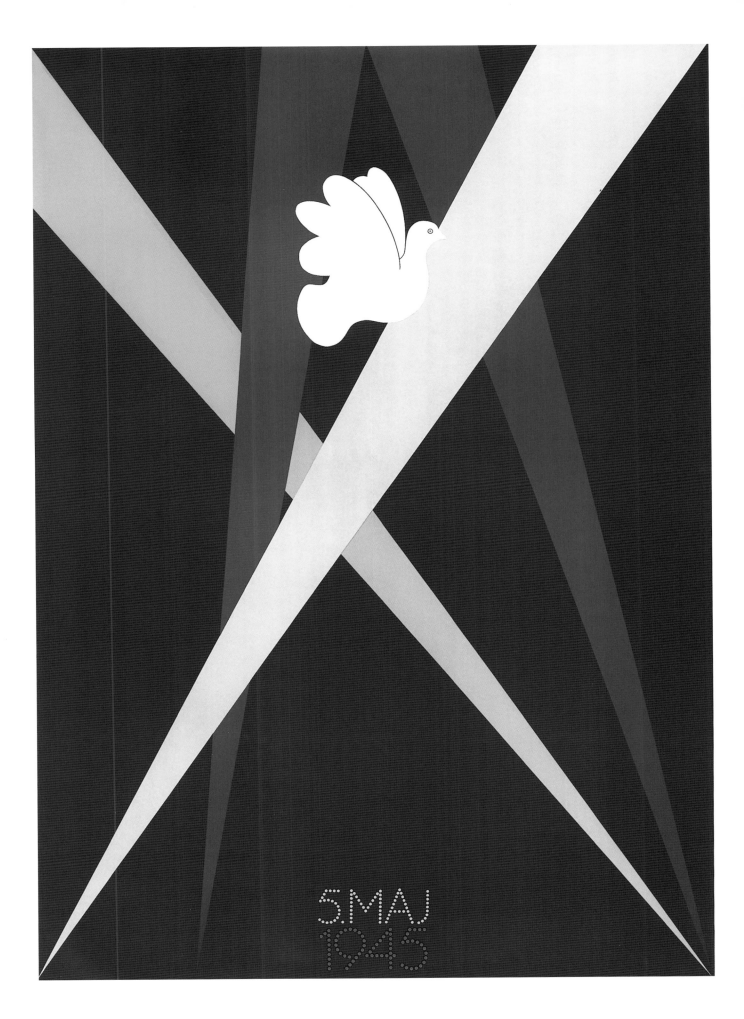

LABORATORY TECHNICIANS' SCHOOL

LOGO ∧
1993

ECOLOGY JAPAN

POSTER FOR >
GRAPHIC MESSAGE FOR ECOLOGY
70 x 50 CM
2000

" The exercise is very simple, and surely it has to be if you dream of being heard and understood in Japan, where the public as well as the other participating artists know all about simplicity and the power or powerlessness of serenely simple symbolism. My green heart!"

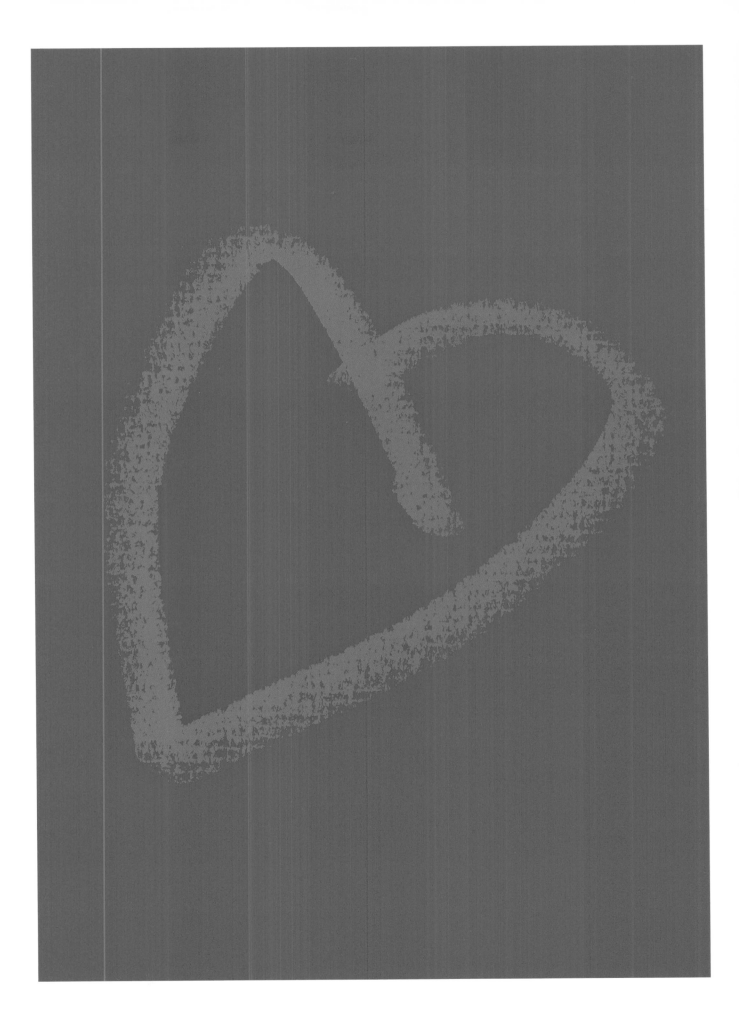

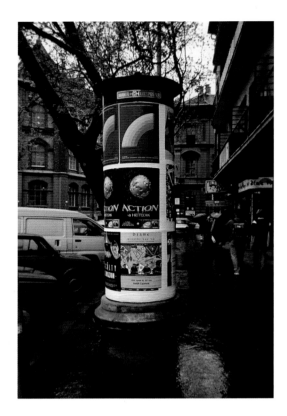

COUNCIL OF EUROPE 50 YEARS

POSTER <
100 x 70 CM
1999

VICTORIA AND ALBERT MUSEUM

POSTER >
100 x 70 CM
1998

❝❝ If there's any meaning at all in the claim that a good poster speaks for itself and tells its story without messing about, this poster for a poster exhibition at the Victoria and Albert Museum in London is probably one of those that should take very few words with it on its way into the world … it was designed to explode right in the face of the viewer, and that must be enough!"

THE **POWER** OF THE **POSTER**

V&A

1902 2002

NESA CENTENARY

VIGNETTE FOR ELECTRICITY COMPANY ∧
2002

WOLFKING

POSTER >
80 x 60 CM
2002

" The challenge is already there in the name of the client.
Wolfking ... wolf and king – the images were too strong to avoid,
and why should one even try.
And since the factory makes some of the world's most efficient
machines for grinding meat, the teeth just couldn't be big enough
and the king's crown could crown this industrial epic
with suitable majesty, as well as the razor-sharp aggression
well hidden within the shiny smile of the machines."

WOLFKING

S

SUPERFLEX

LOGO /\
1995

MUSIKHUSET AARHUS

POSTER >
100 x 70 CM
2002

" Superflex is a group of artists who made their entry on the scene disguised as a firm ... and of course as a finishing touch the fiction had to have a professional logo.
Superman and Superflex gave me the 'S'... and the three members of the group gave me the accentuation of the three sides or shades of the 'S' or the three perspectives on the matter, in a slightly epic-filmic foreshortening.
And now Superflex is a firm disguised as an artists' group right out there in real life ... and the logo has stayed the course!"

PER ARNOLDI 200 PLAKATER

MUSIKHUSET AARHUS 18. AUGUST – 30. SEPTEMBER 2001
I SAMARBEJDE MED DANSK PLAKATMUSEUM

**REN
BY ?**

1990
Stadsingeniørens direktorat

DESIGN: ARNOLDI

JC DECAUX DENMARK

POSTERS >
175 x 118 CM
1993 / 2003

JC DECAUX ABROAD

POSTERS >>
175 x 118 CM
1991 / 2004

““ A very long success story told
very briefly ...
My poster for Copenhagen City Council
and a cleaner city in 1990 led to a
close collaboration with the French firm
JC Decaux, which besides covering 11,000
other towns all over the world was also
making its debut in Denmark. Since then
I've designed over 50 urban posters
for JC Decaux, but posters of a slightly
different character ... I mean, there are
posters and there are posters.
A real poster, you could say, is used
anywhere else but in the very town it
promotes ... See Naples and die etc. ...
But my city posters for JC Decaux only
appear in the towns they are about, so they
function more as a celebration of the
place they were ordered for, and as a
kind of decoration of the public space in
which they appear ... but shouldn't all
posters do that?
And then of course this context has the
striking difference that I can use a set of
codes, coats of arms, buildings, locations
etc. ... which only have to and perhaps
only can be deciphered on the spot.”

303

ÅRHUS

SMILETS BY

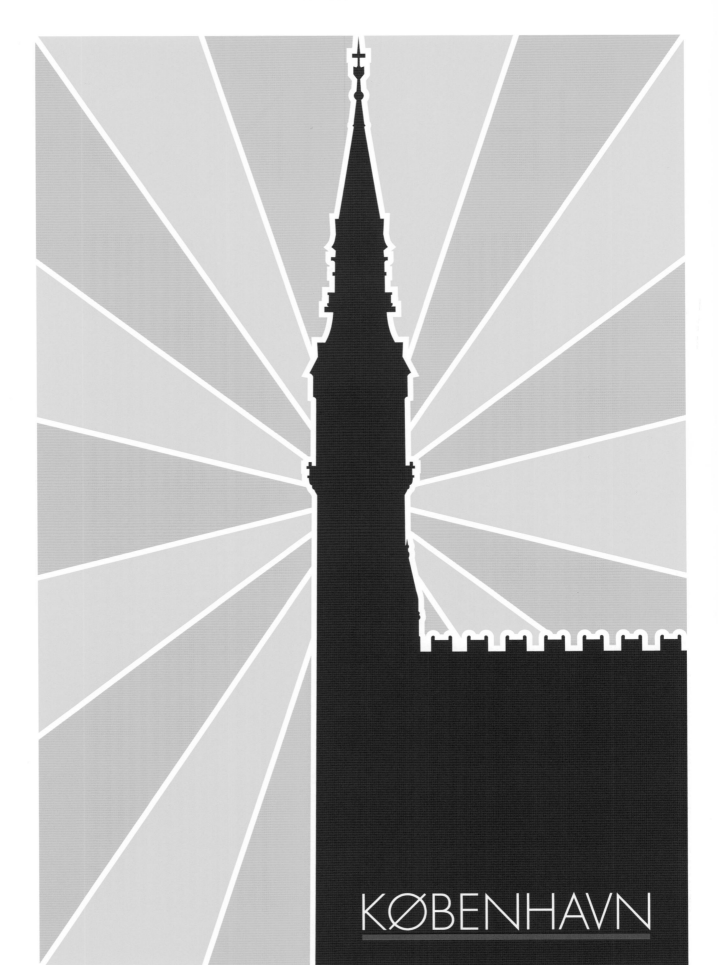

FREDERICIA

HILLERØD

FREDERIKSBERG

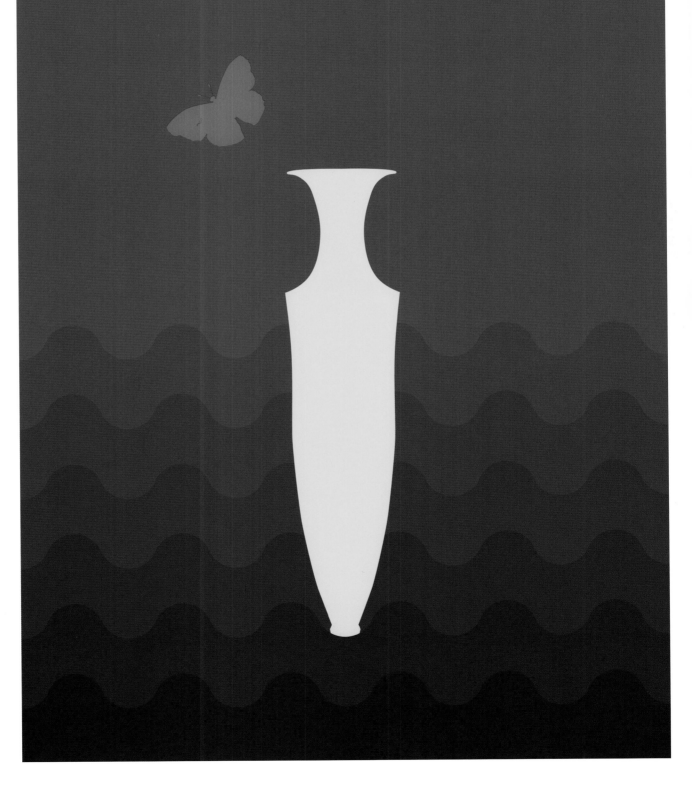

RANDERS

KOLDING

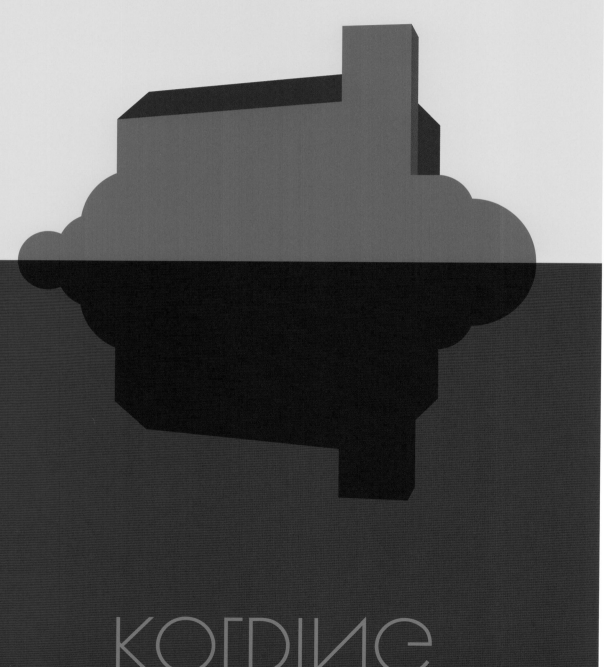

KOLDING

HORSENS

ODENSE

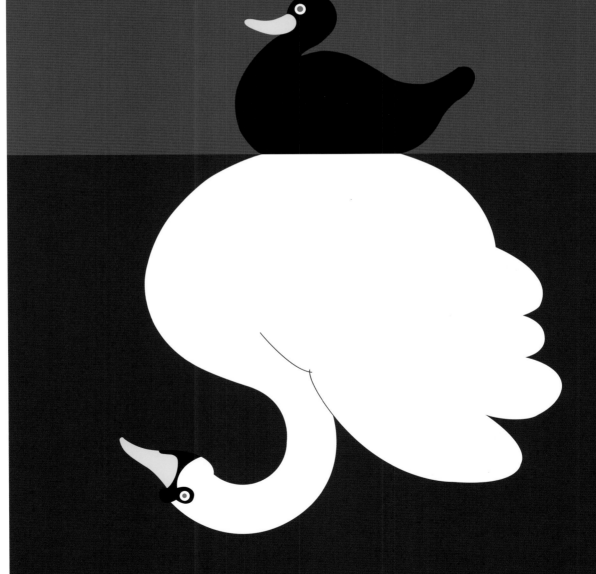

N

SVENDBORG

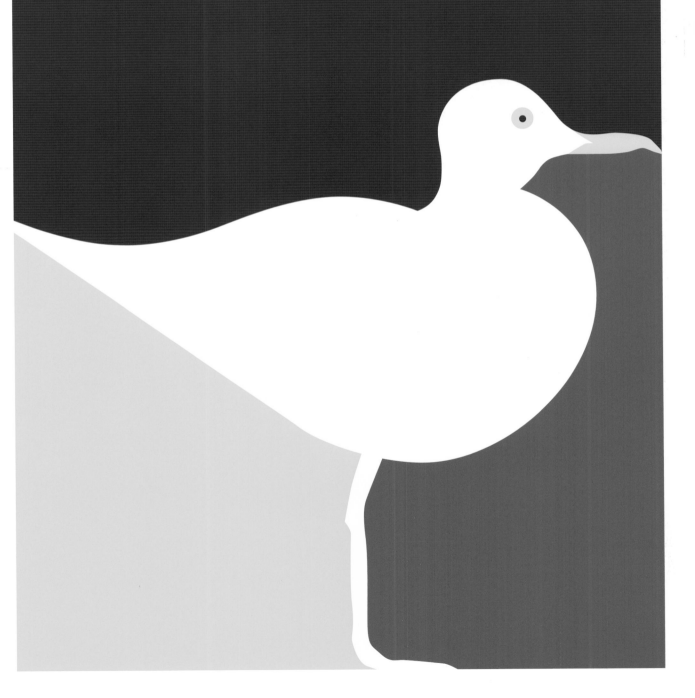

The Royal Borough of

KENSINGTON and CHELSEA

STOCKHOLM

1252　　　2002

UNITED NATIONS
1945
1995

UN CHARTER SIGNED JUNE 26. 1945 IN

SAN FRANCISCO

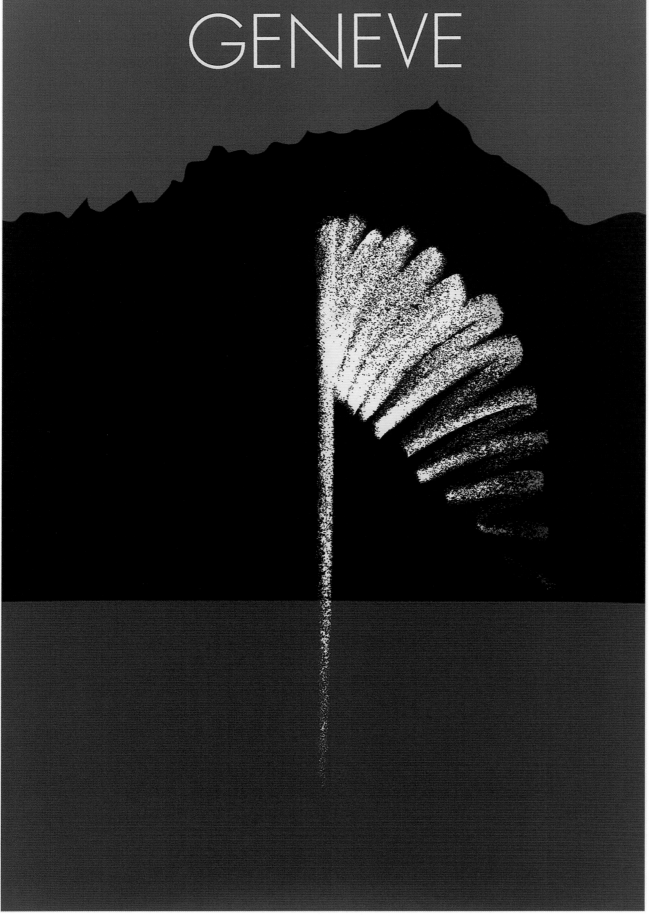

999 - 1999

SAARBRÜCKEN

PRAGUE

MUSIC FESTIVAL 1996

FRANCE WILL NEVER FORGET

D-DAY JUNE 6 1944 60 YEARS CELEBRATION 2004

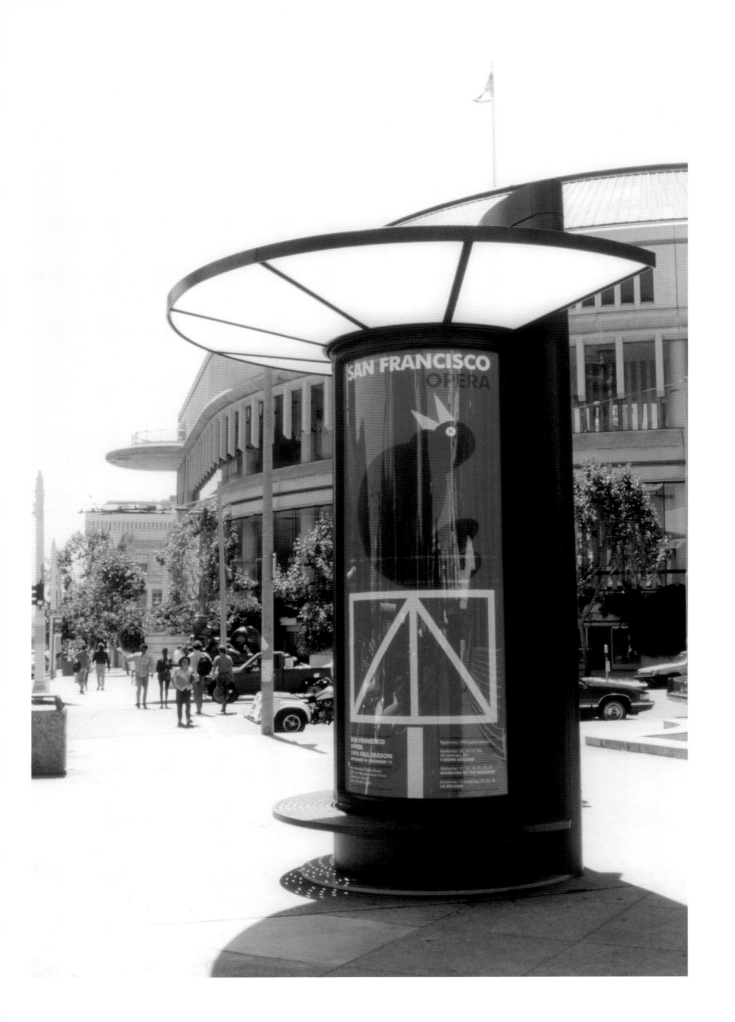

"Although it is perhaps only a play on words, I like the idea that 'finding' a motif also means that before you can find it, it has to be 'to be found'. To say that something 'is found' can mean either that you have looked for something and found it, or that it simply exists ... whether you look for it or not; that the thought, the narrative that is striving towards form, clarity and articulation, is already concentrating and hardening into a final shape, *taking* form before we *give* it form; and that my task is thus more to localize this 'form in embryo' and bring it out into the light. Deliver it!

The worn-out Picasso quotation "I don't seek, I find" is very precise. You *cannot* strain to seek, you can only find ...

And he did that in a more manic, direct, relentlessly curious, incessant and better way than most.

Now and then when teaching I have used the slightly clumsy image that an idea, a finished form, is an egg that is waiting to be laid. That the designer in the broadest sense is the hen and the rooster is beyond our ken ... At the same I have become fond of the obviousness of seeing the artist as a hen, a good broody one, ready to deposit its eggs ... Comical, but the point is fair enough: the hen is no hero!

It only has to be there when the egg is to be laid...

And as a rule the eggs are in top form! Time lays its eggs on time, when the form has been perfected and *cannot* be otherwise. That is why all images are images of their time whether you want them to be or not ...

No artist is ahead of his time. No chicken ahead of its egg!

This book contains about half of the posters and logos I have designed over thirty years. Ordered, or rather disordered in a chaotic bouquet of the themes that have been evolved and revolved again and again.

It has been my good fortune that the same subjects and sometimes the same clients have come back to me and have forced me again and again to 'search' for yet another definitive image for jazz and railways and ballet etc.

It is almost impossible to describe the state you have to get yourself into to be able to – not seek, but find and complete the simplest symbol. But you cannot force the process. All eggs take time. You have to be completely convinced that the symbol you must find is in fact 'to be found' somewhere out there – or in there.

And it would be very strange if one were so unlucky as to be there on the very day when all language, all signs, all images and symbols had been used up!

That would be the end of the world."

Per Arnoldi

PER ARNOLDI 250 POSTERS ETC.

© 2004 PER ARNOLDI
COPENHAGEN DENMARK

DESIGN:
PER ARNOLDI
WITH
MORTEN AGERGAARD
ANNETTE BOTVED
BERIT IRENE OLSEN

TRANSLATION: JAMES MANLEY

TYPEFACE: BODONI AND FUTURA

PROJECTS MARKED • HAVE NOT BEEN REALIZED

PRINTED IN DENMARK BY:
ROSENDAHLS BOGTRYKKERI

BINDING: JYSK BOGBIND, DK

PHOTO:
ROSTED
BENT RYBERG
MALLE
HANS OLE MADSEN
E.A.

PUBLISHED AND DISTRIBUTED BY
BIRKHÄUSER-PUBLISHERS FOR ARCHITECTURE
P.O.BOX 133, CH-4010 BASEL, SWITZERLAND
PART OF SPRINGER SCIENCE+BUSINESS MEDIA
WWW.BIRKHAUSER.CH

ISBN 3-7643-7097-1
987654321

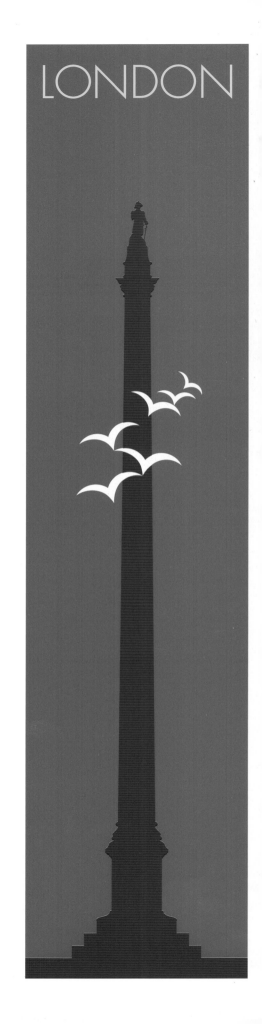

LONDON